Selected Art Centers of the
Northern Rocky Mountains

MINOT

MISSOURI R.

OMAHA

A Brush
With the West

A Brush with the West

Dale Burk

Introduction by Vivian Paladin

Mountain Press Publishing Company
Missoula, 1980

Copyright 1980
Dale A. Burk

Library of Congress Cataloging in Publication Data

Burk, Dale A.
 A brush with the West.

 Includes index.
 1. Rocky Mountains region in art. 2. The West in
art. 3. Art, American—Rocky Mountains region.
4. Art, Canadian—Rocky Mountains region. I. Title.
N8214.5.R57B87 704.9'49978 80-24728
ISBN 0-87842-133-5
ISBN 0-87842-134-3 (lim. ed.)

MOUNTAIN PRESS PUBLISHING COMPANY
P.O. Box 2399
Missoula, Montana 59806

For two women
who have always encouraged me,
and whose love of art
is as boundless as my own:

Marie Louise Burk, my mother
Doris Glass, my mother-in-law

Contents

Plates

Illustrations

Foreword

Man has always had one over-riding difficulty. That is an inability to assess or even be aware of significant trends as they are lived through and witnessed. Whenever someone has made an observation which turned out to be meaningful, there has always followed the maddening cliché, "I told you so." With most of us, another cliché usually applies, one less maddening, more human, but saddening: "Hindsight is better than foresight."

This lack of understanding a trend, one that may not be world-shaking but which today commands the attention of an inordinate number of people everywhere, happened to us in the American West. And the lack of understanding went on for a long time. That trend has to do with the artistic delineation of the history, the landscape, the wildlife and the people of one of the last pristine regions left on this continent.

Our lack of understanding caused us to think of Karl Bodmer and George Catlin as somewhat stylized bores who cluttered up our textbooks and encyclopedias. It caused us to think of Charles M. Russell as a cowboy who told funny stories but whose art filled more bunkhouses and saloons than it did galleries and thus was of little value except to his friends, who thought it was nice to have a memento from "good old Charlie." Even then, most of them eventually gave Charlie's work away, or lost it, or sold it to someone (usually

from out-of-state) smart enough to recognize its worth.

In this book, Dale Burk sets out to explain the trend, trace its growth and assess its impact today. He has taken on a considerable task, for like all matters of significance, this one has many facets. There are many exceptions to one's conclusions, there are many sides to every theory, to every explanation of why this region has at last become a serious and respected place. Indeed, no matter how much we investigate and point with pride, there are still nagging doubts that we have made all that much progress in the cultural life of the American West, specifically the Northwest Region. We're still a little embarrassed about it and still eschew many of the snobbish trappings which have historically been associated with culture and the arts.

Nonetheless, this is an analysis long needed. This writer, as pointed out in Chapter Five, went through a personal travail before it dawned on me and my colleagues at the Montana Historical Society that our quarterly journal, *Montana, the Magazine of Western History,* could become a vehicle for using documentary art and that indeed we dared use artists other than C.M. Russell, great as he was.

Awareness of Russell's true greatness had come earlier, of course, after the loss of the Mint Collection in Great Falls to Texas and after Dr. K. Ross Toole used every huckster device known to acquire the Mackay Collection (at a give-away price) for the Society. There was a long time, before my tenure, when only Russell was used on the front covers of the magazine. No one complained much, because of the greatness of his work.

But then came the realization that there had been other greats in the past — even those I had once thought of as stylized amateurs. The truth was that these men, following close upon the heels of Lewis and Clark, had left the only record we have of what this country and its inhabitants looked like. Investigation soon revealed that there was a rich treasury from which to draw.

At the same time, it became obvious that a new body of contemporary art, increasingly excellent, was emerging. There then came the decision to keep the magazine clearly focused on history, which meant that no living artists would

be dealt with in depth. It was a hard decision, but a sound one, as it turned out. The mission of depicting and explaining good contemporary art is now being admirably fulfilled by a number of publications. Notable in our region is *Art West,* published six times a year in Kalispell and Bozeman.

Meanwhile, in the galleries of the Historical Society and many others, art of growing quality was being shown. Artists began organizing themselves into groups which imposed increasingly rigid standards of excellence. Qualified experts within and outside the region were called in to jury it. The "good ole boy" syndrome of who to invite and show has largely given way to an undeniable professionalism, although it is a fact that western artists are generally easy to like and most of them like each other.

As Dale Burk points out, there has been and is some badly done art still around, ground out by those who want to jump on the bandwagon. There are forgeries of great art and some sad cases of exploitation. From my vantage point now, however, after spending some twenty years passing up opportunities to acquire the great western art I have seen, the genre has arrived. Every art show that I know of increases in quality every bit as fast as do the prices. There is buyer discernment everywhere evident. Shoddiness does not sell. And the great contemporary artists in this now-recognized school of art, whether they live in Montana, Arizona, Colorado or Connecticut, will endure.

<div style="text-align:center">

Vivian A. Paladin, Editor Emeritus
Montana, the Magazine of Western History
Helena, Montana

</div>

Introduction

One doesn't undertake an endeavor such as *A Brush With the West* lightly. The practice and business of art in the American West, and the Northern Rocky Mountains in particular, are serious enterprises and one encounters a real or imagined expert at each turn of the trail. I do not claim to be either, but do profess a profound and genuine admiration for those whose artistic skills capture the essence of this land we love.

Paradoxically, the idea for this book came on a visit in 1976 to an art museum in Quebec, Canada, and I am grateful to the person there who suggested that something quite extraordinary was occurring with art in the Northern Rockies. I mused over the idea for months, waiting for the time to do a book and fearing, constantly, that someone else would come up with the same idea. Fortunately, for me at least, that did not happen. *A Brush With the West* is now a reality, thanks in large part to many individuals who assisted me at one point or another.

Those who assisted know who they are. I thank each of them. However, several individuals gave immeasurable assistance in the form of hard labor and encouragement and I wish to thank them by name: Dick Beighle of Missoula, the

first person in the region to whom I outlined the idea for the book; Bob Morgan and Dick Duffy of Helena; my wife, Patricia; Howard Foulger of St. George, Utah; Thelma Powell of Kalispell; Michael Kelly, Bernice Porter and Debby Stambaugh of the Buffalo Bill Historical Center in Cody, Wyoming; Judith Greene of Stevensville, who assisted in preparation of the manuscript; Robert Archibald, Director of the Montana Historical Society; the Fine Arts Department at the Glenbow Museum in Calgary; Rosiland Ellis at the Detroit Institute of Arts; Carol Roark of the Amon Carter Museum; and the staffs at the Boston Museum of Fine Arts and the Joslyn Art Museum in Omaha.

Dale A. Burk
Stevensville, Montana
November, 1980

chapter one
A Brush With The West

THE MYSTIQUE of the Northern Rockies began with Lewis and Clark and has increased with the passage of time.

It is different now, of course, than it was in 1805-06, for both the land and its people. Time and history have taken care of that. The Old West has given way to the *new* West; the reach of its people has changed. People today grasp for meaning in different directions; for Lewis and Clark the vision was toward the future and continental expansion as envisioned by Thomas Jefferson; the land and its riches were awaiting settlement and conversion to the white man's way of life. Today we also find meaning in looking backward, in reassessing those images and insights telling us not so much what we are as what we would like to think we are — or have been.

That land we know as the Northern Rockies has been a long time in the defining as a geographical entity like the Southwest, New England, or the Deep South. Part of that was due to the procession of settlement and politics into the region. Early-day cartographers split the area asunder, creating schizophrenic notions that only the region itself, with the healing grace of time, could erase.

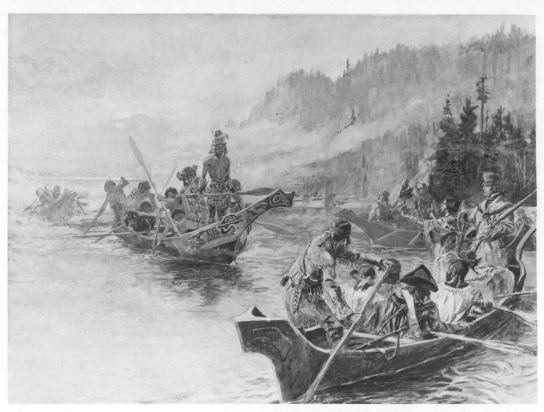

C.M. RUSSELL

*Lewis and Clark
on the Lower Columbia*

Courtesy:
Amon Carter Museum
Fort Worth, Texas

Others, empire builders, city boosters, and travel promoters, envisioned portions of the area as belonging somewhere else. They subsequently sliced the area up. Seldom has it been considered for its geographic whole as an entity capable of shaping its own culture and, among other things, artistic expression. Consequently, portions of the Northern Rockies have alternately been known as part of the Louisiana Territory, the Dakota Country, Oregon Territory, Washington, Pacific Northwest, Northern Plains, the Inland Empire, and others. Of the labels, only one — The Land of the Shining Mountains — recognized the uniqueness of the area as a geologic and geographic region unto itself.

Of course, the area was, and is, headwaters country for two of the world's great rivers, the Missouri and the Columbia. It also spawns major river systems that feed a third ocean, the Arctic, along its northernmost section.

These rivers served only to draw the region's identity to labels given other geographic entities. The Northern Rockies were carved up and apportioned to whatever area might want to claim them.

Part of the region's early identity problem rested with its most decisive feature, the Continental Divide. It was easy to look at a map and assign part of the area to the Pacific North-

2

west, and part to the High Plains. It spawned rivers going to those places, and from the beginning of its economic exploitation by the white man, first furs, then gold and silver, then cattle, its convertible values were shipped out to those downstream regions.

Yet throughout its history since Lewis and Clark, the Northern Rocky Mountains enjoyed a special romance in the hearts and minds of the American people. The land and those lives that shaped it made it so. So did legends, some living, others created by the mind and literary power of writers like A.B. Guthrie, Jr., whose *The Big Sky* gave the world new perceptions of the mountain man and his country.

So did real people: John Colter and William F. "Buffalo Bill" Cody and John Bozeman, Colonel George Armstrong Custer and his nemesis, Sitting Bull, and Marcus Daly. They each embody the reality and myth of the Northern Rockies and its place in the West.

Countless others walked with them, or in their footsteps. The mountain men numbered no more than two hundred and yet captured the world's imagination as no other adventurers could. Prospectors followed and their ore strikes brought settlement and civilization to the region. Then came the cattlemen, sheepmen and merchants; in turn the sodbusters came with their plows and permanence. So did the logger and lumberman, missionary and, ultimately, enough people to alter the way of life. The area's culture changed from that of nomadic, Indian tribes to a white-oriented society bent on wresting a living from the region's land that was, and is, so rich in mineral and agricultural wealth, and yet so fragile.

Vast changes were wrought in the land and to its people. The demise of the buffalo guaranteed the demise of Plains and mountain tribes who depended on it for subsistence. Much of the prairie gave way to cultivated crops; roads and railroad tracks crisscrossed the plains and snaked their way through impassable mountain canyons.

Now we define the Northern Rockies as that area from Denver north into Alberta and British Columbia, extending from the mountains' eastern-most extremities in the High Plains to culturally-similar ranching country in eastern Washington. It includes northern Colorado, Wyoming, Mon-

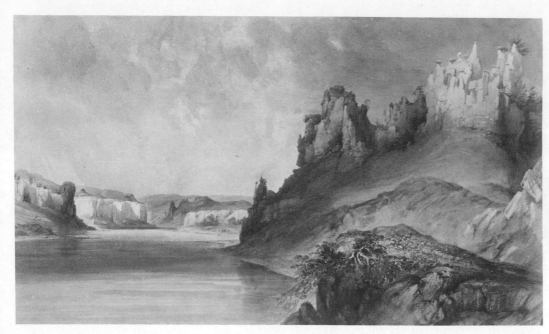

KARL BODMER
*View of the Passage
Through the Stone Walls*
Courtesy:
Joslyn Art Museum
Omaha, Nebraska

tana, Utah, Idaho, eastern Washington, and parts of British Columbia and Alberta.

The Northern Rockies is rich in both historic art and in that contemporary work intended to capture on canvas or in bronze the essence of the land and its people. The present is largely akin to the past; it is still possible to have a brush with dangers of the Old West in the Northern Rockies. To be sure the warring Indians are gone; almost everything else can be found much like it was in the time of Charles M. Russell or perhaps, as sketched by those word painters, Meriwether Lewis and George Clark.

I mused about such things recently on a knoll overlooking the Missouri River in northcentral Montana. It was a bright, soft, blue-sky autumn day without clouds, and the morning cool along the river soon gave way to an overpowering, humid warmth. I sought comfort in the shade of a deep-cut Bearpaw shale bank. Inches away the Missouri swished effortlessly by, its gentle flow the only discernable sound in that silent wilderness. Solitude ruled the land as surely as it had in 1805 when Meriwether Lewis described the same stretch of the Missouri. He was much on my mind as I sat where he might have sat. I know my feelings were as he described: "It is beautiful in the extreme."

So it is today with other aspects of the Northern Rockies,

4

particularly natural features and wildlife. My brush with the West could well be described in terms used by Lewis almost two centuries earlier. So, likely, could yours.

The Northern Rockies are distinct. They are unique. They harbor, still, two magnificent creatures, the grizzly bear and the elk. There are still wild, free-flowing rivers with impassable rapids and, in quieter headwaters, beaver and muskrat and poplar thickets much as the early-day fur trapper found. There are vast stretches of true wilderness, undefiled and laden with game and challenge. Winter snows still hang to steep cliffs and weathered ridges, swept by chilled winds. The shining mountains exist in reality as well as legend.

Space is there, too, but not the awesomeness of distance. Civilization is as near as the closest road; one needn't float the Missouri to St. Louis to find civilized company.

The major exception is that the overpowering element of risk in the early days is gone from the high plains and mountain reaches of the Northern Rockies. Indian war parties aren't out for your scalp; their culture and way of life are mostly gone now, a part of the past we're still trying to understand.

Still, life in the region is shaped today by forces that controlled it in Lewis and Clark's time. Weather is a dominant factor. Winters are long and severe; a major limitation on enterprise. So is aridity. There is enough distinct harshness and unpredictability to the weather to demand respect. Recurring drought is a way of life in much of the area.

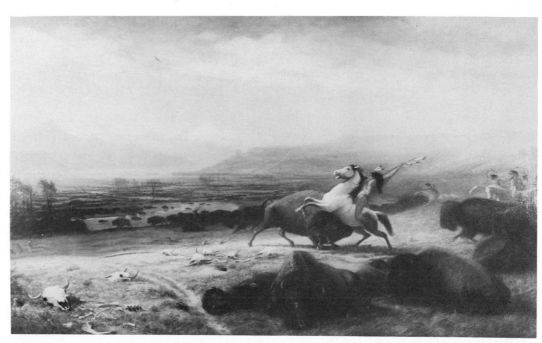

ALBERT BIERSTADT
Last of the Buffalo
Courtesy:
Buffalo Bill Historical Center
Cody, Wyoming

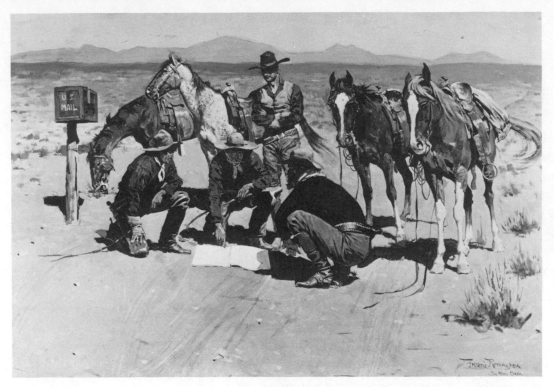

There is cowboy work today. Agriculture is the major business of the region and cattle operations are significant almost everywhere. Prospecting still occurs, as does mining and trapping. For some in the Northern Rockies, history is as it was — with refinements, of course — as the world-wide romance with the cowboy myth continues.

While transition has occurred in the Northern Rockies, the affinity of the new with the old is ever-present and overwhelming. Consider, for example, this challenge: name one town, of any size in the region, in which a print of a Russell or Remington painting is not displayed. Just one! I doubt that you can. Besides their decorative quality, these works provide a psychological link to our past — as we want to remember it.

There is a transcendent drama to the Northern Rockies. It is simple, for example, to fantasize that things are, or at least seem to be, the same as when Lewis and Clark were here — as I did that day on the Missouri. The lure of the high mountains and the quiet alpine meadows still beckon; droves of summer visitors throughout the region are witness to that.

Adventure is found within the region — timelessness — awe — inspiration — and notions that lift you out of today. Fantasies transport you to the cry of the threatening war whoop and the musky smell of beaver pelts. There is the reality of the

strain of the climb to the crest of the next ridge. The land itself strengthens the affinity of its inhabitants, its visitors.

Why is this so? And why has the region's art mushroomed in recent years to crescendo proportions?

The answer can be summed up in one paragraph: because there is something with meaning to be said about the region, its history and its way of life — about life, whatever the generation. The mystique of the Northern Rockies is that it embodies and enhances humankind's deepest search for meaning in the relationships of people to people, the capriciousness of the land, and its wild creatures. Indeed, it commands a response. There is no equivocation about relationships in the Northern Rockies, no ignoring them. Truth is exposed with searing finality at every bend, every step of the trail.

Artists, whatever their medium, have always insisted their pursuit is truth, meaning, and universal values. These artists always come forth at times and places that inspire special insights. The Northern Rockies is a place that inspires such efforts. There may or may not be a "school" of art in the region. That is of little significance alongside the realization that, however defined, the Northern Rockies has emerged as a major center of regional American art.

For years the Southwest was *the* center of art of the American West, but that singularity began to soften in the 1960s. While the Southwest is still a dominant force, it is not the only one. Indeed, it may be giving way to a newer, more vital and diverse region. Art of the Northern Rockies has come of age; it has proclaimed, from its internal strength and presence, its standing with other regions whose power of life and artistic expression identify them.

"We very definitely have a regional identity," gallery owner Dick Ettinger of the Flathead Lake Galleries in Bigfork, Montana, says, "and it rides on the fact that people in the area, particularly in Montana, have been interested in art of the region for close to a hundred years."

Ettinger's roots are in the Southwest. In fact, he began his own involvement as a dealer in Albuquerque in 1965 and moved to Montana in 1976 when he purchased his present gallery from its founder, O'Neil Jones. Ettinger believes the widespread interest in art at all levels of society in the North-

ern Rockies, plus the region's scenery and distinct seasons, are at the root of its emergence as an artistic center.

A young Montana landscape painter, Clyde Aspevig of Billings, proclaims that an overwhelming abundance of subject matter along with exuberant competition among the region's ever-growing number of artists has resulted in its recognition as a center of quality art. Wildlife artist Veryl Goodnight of Englewood, Colorado, put it this way: "The concentration of talent that exists in the Northern Rockies alone should be reason enough for a school to develop, but when you combine that with the most spectacular scenery in the entire United States as well as some of the most colorful history and concentration of wildlife and outstanding working ranches, it would be difficult for the area to not achieve its own identity."

Two aspects are clear from such observations. One is the immediacy of subject matter in the area today. The other relates to the region's history. Consequently, its art is both contemporary *and* historical; both appear regularly on the canvases and in the sculptures produced in the region.

Goodnight referred to the "allure" of the region's subject matter which, for her, is wildlife. Sculptor Clark Bronson, formerly of Utah but now of Bozeman, Montana, emphasized the availability of live wildlife to observe within easy driving distance of his Gallatin Valley home. And for painter James Bama of Wapiti, Wyoming, it is living history.

Peter H. Hassrick, director of the Buffalo Bill Historical Center at Cody, Wyoming, wrote in an introduction to a book about Bama's work: "Bama's people are living history. 'They are not,' as he says, 'make believe, Hollywood shoot 'em up people. They are people who stand here today. People who are a part of the greatness of Wyoming, the rodeo and the reservations. There is a lot of history out here. It is very exciting and very personal. I absolutely love it and am impelled to put the parts together as a puzzle. Wyoming is young enough, and concentrated enough, so one can piece the picture into an integral whole.' "

For others there is history recounted, be it depicting the Lewis and Clark Expedition, the fur trappers, mountain men, or the cowboy and Indian days. The region's past is too rich to ignore.

8

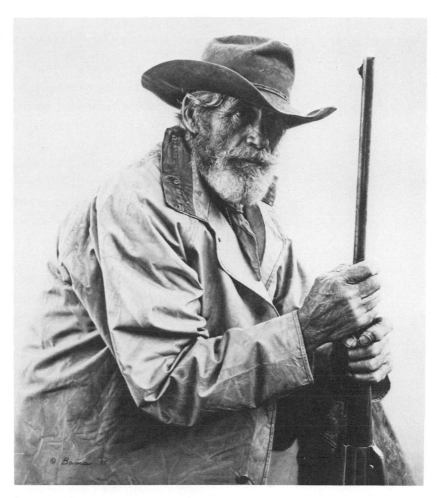

JIM BAMA
*A Portrait
of Al Smith*
Courtesy of the artist

"The period of our early regional history, 1805 to 1890, represents a bygone era so desirable that an individual quickly identifies with it and wants for it to continue to live," John R. Brice, director of the Hockaday Center for the Arts in Kalispell, Montana, said. "And the more there are trappings around them (the general public), of any kind, that reflect that time, the more likely they are to conjure it up."

Editor Kathe McGehee, of the fine publication *Art West*, itself a product of the burgeoning interest in western art, suggests that a new generation of artists is changing the whole thrust of western art. "Western art is no longer the cowboy and Indian art which the cowboy artists of America fostered earlier," she said. "There's a whole new generation of young people involved." She suggested that some of the most significant and dynamic art to be found in the U.S. today is in the West.

The day of our interview, McGehee had just returned from a visit to the studio of painter Steve Seltzer (grandson of O.C. Seltzer) where she had interviewed and photographed him for an *Art West* article. She was still excited about the prospects of that story.

"We've turned the tables on the East," she said. "In the 19th Century, everything considered of value came from the East to the West. Today every aspect of our western culture is literally sweeping back across the East, be it Levis or the image of the Marlboro man. Our art today is folk art in the strongest sense."

This phenomenom was not without its prophets. The late artist Ace Powell philosophized throughout his up-and-down career that the region, particularly Montana with its heritage of Charles M. Russell, would rise to major prominence in American art.

Another prophet, who wasn't specific to the Northern Rockies, but who foresaw the significance of western art as early as the 1940s was Dr. Harold McCracken, now in his 86th year.

McCracken wrote in the early or mid-1940s (he couldn't remember the date with preciseness) an introduction for a New York gallery booklet on "A Distinguished Collection of Western Paintings Offered for Sale." In it, he set the stage for what would follow in the coming years — events, incidentally, helped along by McCracken's own vigorous support and di-

Dr. Harold McCracken,
Director Emeritus of the
Buffalo Bill Historical Center,
Cody, Wyoming

rection as founder and director of the Whitney Gallery of Western Art in Cody, Wyoming.

"The rapidly increasing popular interest and appreciation of Western American Art is a natural one," McCracken wrote. "It is based on several substantial precepts, much deeper than mere glamour and more important than nostalgia. The epoch of our Old West is only now beginning to find its true perspective in our national history. It laid the foundation for our great nation as it is today and set the pattern for our indigenous characteristics. The dozen or more extremely virile, colorful and clear-cut types of our Western era are un-adulterated American — the mountain man, frontier scout, cowboy, squaw-man; covered wagon-men, Indians, and all the rest. Rough and sometimes transgressive as they were, here is our national background, and we now find it very healthy and inspiring to look back upon. In these days of vacillating ideologies, it is particularly good for our souls and good for our children."

That interest and public appreciation mushroomed in subsequent decades, to the point that in 1969 I wrote in *New Interpretations* (about Montana artists):

"Let's just say it has become obvious that an extraordinary movement — quite unrealized — has developed. These Montana artists have, without formality or for that matter having any combined sense of direction or knowledgeable cohesiveness of intent, established an artistic trend or school of art. They have created their own school of realistic interpretation of the West — their west and that of their forebears. Their work tends toward the telling of the story of their land and people — native born and adopted — in a way they see and understand it."

Where then, are we now? Far beyond Montana and Wyoming, although that part of the Northern Rockies remains central to the art of the region. Art in the Land of the Shining Mountains has come of age. It is not now tied to anywhere else, or defined and limited by an outside yardstick. It is its own.

chapter two
The Foundation

THOMAS JEFFERSON erred when he failed to assign a staff artist to the Lewis and Clark Expedition, a fact that Meriwether Lewis himself might well have been lamenting on June 13, 1805, as he scribbled in his journal near the Great Falls of the Missouri River.

Caught up by the splendor of the falls, Lewis at first tried to describe its beauty in "wrighting" and then wished he had brought a "crimee obscura" (camera) with him to capture the "majestically grande scenery." "I wished for the pencil of Salvator Rosa or the pen of Thompson, that I might be enabled to give to the enlightened world some just idea of this truly magnificent and sublimely grand object, which has from the commencement of time been concealed from the view of civilized man; but this was fruitless and vain," he wrote.

Artists and nonartists alike have subsequently had that same feeling. It is no small task to give a "just idea" of the "magnificent" terrain of the upper Missouri, or the rest of the Northern Rockies for that matter. Many, however, have tried.

It is that notion of a just idea, a correctness — containing within the presentation of what is portrayed or perceived to

12

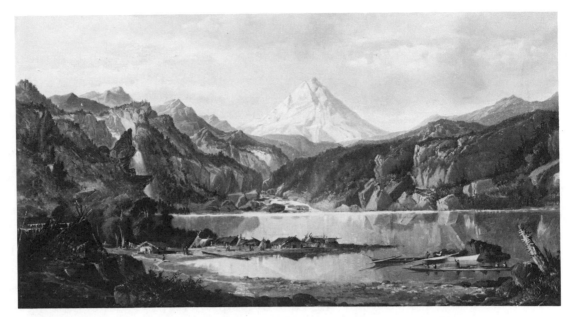

JOHN MIX STANLEY

*Mountain Landscape
with Indians*

Courtesy:
The Detroit Institute of Arts
Detroit, Michigan

be the real story behind it — that has come to characterize art of the region. Reality is basic, whether applied to what is obvious or what may not be.

Our images of Lewis and Clark's epic journey come only in the form of imaginative portrayals by later artists. We can only hope, if those portrayals are not minutely accurate, that they give a just idea of the expedition members and what they were doing. Fortunately for the explorers and for us their epic is bigger than life. They made a grand conquest of a previously uncharted region and set a tone of adventure, daring, sacrifice, and minute attention to detail that is reflected in the work of almost everyone who has tried to paint or sculpt them.

The artistic foundation began with the works of two men: George Catlin (1796-1872) and Karl Bodmer (1809-1893). A third, John Mix Stanley, (1814-1872) also did significant paintings of the region, but a fire at the Smithsonian Institution in Washington, D.C., in 1865, destroyed most of this less prolific artist's work.

Pennsylvanian George Catlin, whose grand purpose was to paint and record the disappearing culture of the American Indian, was the first. That ambition brought him to what is now Montana in 1832. Like Bodmer, Catlin met William Clark of the Lewis and Clark Expedition, accompanying him in the

13

early 1830s on trips to the north-central prairie country. At the time Clark was Superintendent of Indian Affairs for the Western Tribes headquartered in St. Louis, Missouri. In 1833 he would assist Bodmer (as he had Catlin) prepare for his trip to the Missouri headwaters.

Catlin's frontier excursions lasted eight years and resulted in 600 paintings. He achieved success beyond his wildest dreams, though he might not have fully realized it in his lifetime. He went into the American West with a purpose, "inspired with an enthusiastic hope and reliance that I could meet and overcome all the hazards and privations of a life devoted to the production of a literal and graphic delineation of the living manners, customs, and character of an interesting race of people who are rapidly passing away from the face of the Earth."

The "just idea" had raised its head again. Catlin did achieve a literal and graphic delineation of his subjects and left an incomparable heritage. Unfortunately, it failed to bring him the wealth he had hoped. He went to Europe in 1840, lectured, reproduced his work, and ultimately went bankrupt in 1850.

Nonetheless, Catlin's works are of unusual value from a historical perspective alone. They give more insight and detail to the culture of the Indians he painted than the work of

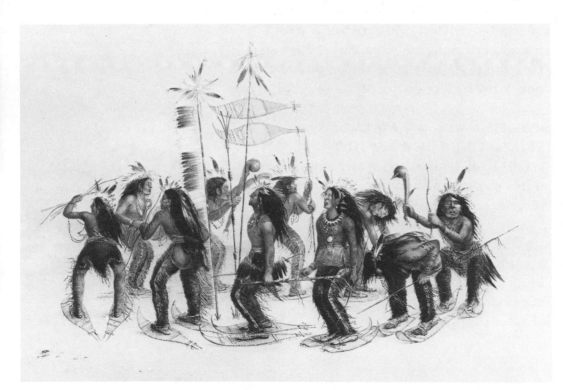

GEORGE CATLIN

Snow Shoe Dance

Courtesy:
Buffalo Bill Historical Center
Cody, Wyoming

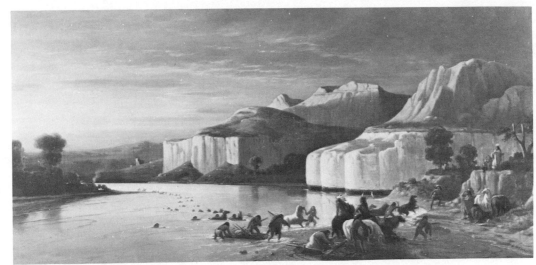

CHARLES WIMAR

Indians Crossing Mouth of The Milk River

Courtesy:
Amon Carter Museum
Fort Worth, Texas

any other artist and serve as a benchmark against which to measure the accuracy of other works. Paul A. Rossi and David C. Hunt, in their excellent book *The Art of the Old West* put it this way: "A tireless traveler, he (Catlin) spent eight years in the western wilds documenting the life and customs of the native tribes of America and another fifteen or more traveling in the East and abroad with his collection of scenes and portraits, lecturing and publishing his 'memorial' to his country's aboriginal inhabitants. Of all the reporters on the American frontier during the early half of the century, perhaps no one regarded the Indian with more respect and genuine sympathy. Certainly, no one tackled his self-appointed job with more energy or sense of purpose."

Catlin journeyed up the Missouri in 1832, on board the American Fur Company's streamer *Yellowstone* (the same boat Bodmer used), to the Fort Union area where the Yellowstone and Missouri Rivers meet. In both paintings and his writing, the Rocky Mountains subsequently are presented in reverent tones. His most historically significant works remain, however, his minutely detailed portraits.

Swiss artist Karl Bodmer, however, became the first artist of stature to paint the landscape of the Northern Rockies. He penetrated the wilderness to the upper reaches of the Mis-

15

ALFRED JACOB MILLER
In The Rocky Mountains
Courtesy:
Joslyn Art Museum
Omaha, Nebraska

souri, and one painting, *Fort McKenzie,* done at the apex of that journey some eight miles north and east of Fort Benton, would have been enough to establish him as a major illustrator of those times. Fortunately, he did many more.

Painted by Bodmer as eyewitness, *Fort McKenzie, with the combat of 28 August, 1833* depicts a gruesome fight between two Indian tribes just outside the walls of Fort McKenzie.

It is a scene of savage, almost bestial frenzy, powerfully capturing the brutality and terror associated with the area's primitive culture. In this one work Bodmer immortalized the precariousness of life on the frontier.

Bodmer was a young man then, 23, and the official artist to Prince Alexander Philip Maximilian of Wied-Neuwied. Maximilian's party was at Fort McKenzie on a scientific expedition to study and paint the Indian tribes of the region. Some forty of the Swiss artist's landscape paintings and studies of the countryside and approximately twenty-five of his Indian portraits are of the Northern Rockies region and represent a priceless historical heritage.

Bodmer's accuracy is particularly significant. Comparisons of his works with scenes today along the upper Missouri show his astonishing commitment to painting the terrain as it existed. Examples of Bodmer's ability to observe include exquisitely accurate portrayals of Castle Rock and a stunning view of the Highwood Mountains of Montana with the Mis-

16

souri River in the foreground. Maximilian's writings incorrectly refer to this view as "the foremost chain of the Rockies," but Bodmer's painting accurately depicts not only the terrain but the mood of the area as well.

A further significance of Bodmer's works is that, except for the short visit of Rudolph Kurz in 1851, it would be some time before another artist even approaching his ability would visit the same area. Consequently, his work affords the only visual insight we have into the landscape of the region in the first half of the Nineteenth Century.

Another artist did visit the region shortly after Bodmer and Catlin, however. Jesuit Father Nicolas Point left not only an intriguing journal of his travels and missionary work among the Indians of the Northern Rockies, but included a vast collection of drawings and paintings. Unfortunately, even though Father Point may have seen more of the region and its people than either Bodmer or Catlin, he did not have the artistic skills of either. His draftsmanship was poor; even so, his record is interesting and helpful, if for no other reason than the original record it represents.

The Canadian artist Paul Kane (1810-1871) left a marvelous record of the Indians of the Northern Rockies. Kane, who was born in Mallow, County Cork, Ireland, came to what is now

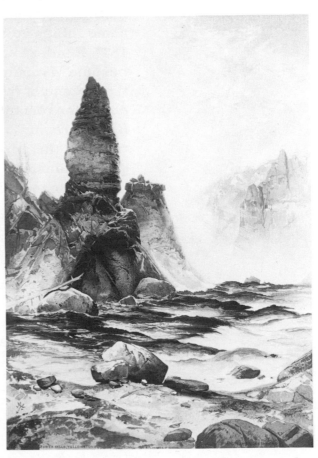

THOMAS MORAN

The Towers of Tower Falls

Courtesy:
Buffalo Bill Historical Center
Cody, Wyoming

known as Toronto with his parents at age eight. In 1846-48 he made a grand trek from Toronto to the Pacific Coast and back — spending much time in the Edmonton area. Indians were his major subject and his legacy is priceless. Piegan, Blood, Sarcee, Cree, Assiniboine, Gros Ventre, Nez Perce and the Metis and many others were depicted by his brush.

Kane, like his contemporary Catlin, left an invaluable historical legacy. Unlike Catlin's, however, it gives insights to Indian peoples and customs on both sides of the Rocky Mountains. Paul Kane, whose intrepid and danger-filled journey gave him insights no other artist had, complemented the work of Bodmer and Catlin. Together the three stand at the base of the region's art.

The second half of the Nineteenth Century saw a plethora of artists visiting and working in the region, but there were five whose impact was profound: Alfred Jacob Miller (1810-1874); Albert Bierstadt (1830-1902); Thomas Moran (1837-1925); James Everett Stuart (1852-1941); and William de la Montagne Cary (1840-1922), who journeyed with an ox-team from Fort Union to Fort McKenzie on the upper Missouri on his first trip west in 1861 and caught, in his sketches, much of the rigor and romance of early trade in the region.

Miller's work was little noticed during his lifetime, but holds special significance today because he saw and painted some things no other person did, among them scenes of the 1837 Rendezvous on the Green River in what would later become Wyoming. Jim Bridger and Kit Carson were among the dozens of trappers at the Rendezvous and Miller's penchant for romantic idealism — he had studied at the *Ecole de Beaux Arts* in Paris in 1833 — may well have laid the foundation for the appeal these adventurers had in later, tamer generations.

The romance of the ideal captivated Miller, so it is no wonder it permeates his drawings. Trappers and the Plains Indians were, to him, the just idea. "American sculptors travel thousands of miles to study Greek statues in the Vatican at Rome, seemingly unaware that in their own country there exists a race of men equal in form and grace (if not superior) to the fine *beaux ideal* ever dreamed of by the Greeks," Miller later wrote.

18

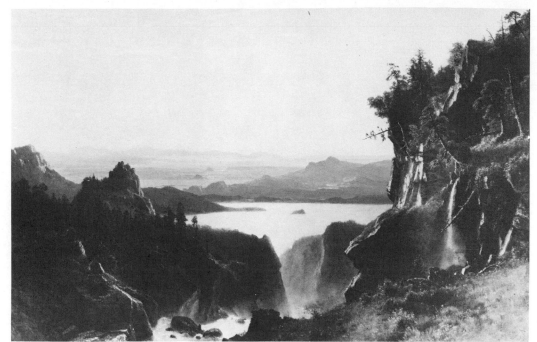

ALBERT BIERSTADT

Island Lake,
Wind River Range,
Wyoming

Courtesy:
Buffalo Bill Historical Center
Cody, Wyoming

Like Miller, German-born Albert Bierstadt presented a romantic, idealized view of the West in many of his paintings. The influence of his training at the Dusseldorf Academy stayed with him throughout his career. Bierstadt came to the Rocky Mountains in 1858 on an expedition under the command of General F. W. Lander, and his romanticized views of the western landscape would — along wth those of Philadelphian Thomas Moran — impress upon two generations of Americans the grandeur of the Northern Rocky Mountains.

Like Bierstadt, Moran enjoyed considerable popularity as a landscape painter during his lifetime and the works of both have been widely reproduced. Yellowstone Park is important in the work of Bierstadt and Moran (though younger brother Peter, and not he, is the namesake of Mt. Moran in the Teton Mountains in Wyoming). Another popularizer of the Yellowstone area was James Everett Stuart, a Californian whose paintings of the Yellowstone Park country helped make it a nationwide tourist attraction.

Other artists were working the scene, too, in the waning years of the Nineteenth Century, but it was mostly these who set the stage for what was to come. The European-oriented white man's culture slowly, inexorably, marched across the continent and with it not only settlement and economic exploitation but a transition from Indian ways to settler ways. The fate of the aboriginal occupants of the region was sealed;

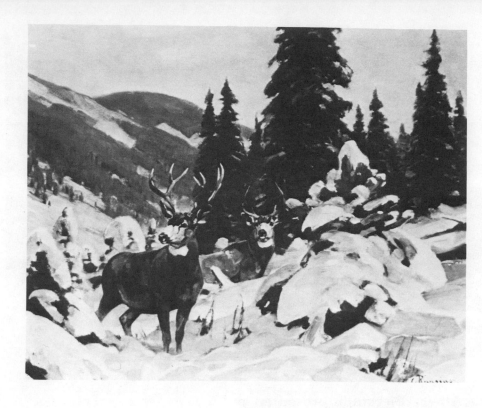

CARL RUNGIUS
Mule Deer
Courtesy:
Glenbow Museum
Calgary, Alberta

their way of life was to be no more.

Images, remembrances of such times are fleeting. And however noble the commitments of artists like Catlin to capture a sense of the time and its people before they disappeared, the "just idea" behind the images is almost impossible to perceive unless the observer is intimately familiar with the subject over a long period. Some would carry that further and insist that the portrayer, whatever the art form, have kinship with his or her subject. They would want them, in the western vernacular, to paint from their guts. From their feelings and their own participation in the just idea comes the substance and authenticity that only visceral affinity can give.

The foundation of art of the Northern Rockies region glitters with the granite firmness of three artists whose work contains that substance. They, more than any other, personify the art of the region. Charles Marion Russell was the most significant of the three in terms of impact and Frederic Remington in terms of capturing at full speed the romance of the American West in transition. Carl Rungius, whose wildlife paintings of the area established a standard of excellence many believe still unexcelled, was the third.

"They are the three R's of art in the Northern Rockies," one contemporary painter said. "Remington for the military dimension and drama of conflict, Russell for the cowboy and

20

Indian, and Rungius for wildlife." Why is Rungius less known outside wildlife circles? Exposure, most likely. "Only one book has been written about him that I know of," Dr. Harold McCracken said. "He hasn't had the exposure, but those who know good wildlife art sure know about him."

It was a Maine hunt in 1894 that first attracted the German-born Rungius to North American wildlife. That introduction led to a long distinguished career, with the Northern Rockies serving as the focal point of his work. An avid hunter, Rungius took his first moose in Wyoming; later he located his studio above Lake Louise near Banff, Alberta. He died in 1959 at the age of ninety and his studio has been preserved by the Glenbow Foundation.

William Shaldach, Rungius' biographer, noted that, "The basis of every Rungius painting is a sketch from nature, made at some particular spot, for the artist is a realist in the true sense." Artist Tucker Smith of Clancy, Montana, sees Rungius' influence as pervasive among contemporary American wildlife artists. He mentioned a National Wild Animal Art Show at the Cowboy Hall of Fame in Oklahoma City in December, 1979, at which Rungius' influence was obvious. "It

Carl Rungius
Courtesy: Glenbow Museum
Calgary, Alberta

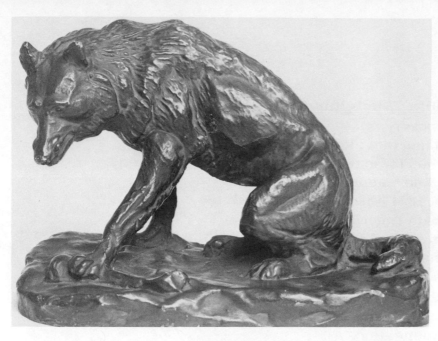

CHARLES M. RUSSELL
Wolf With a Bone
Courtesy:
Buffalo Bill Historical Center
Cody Wyoming

was incredible how many Rungius imitators there were from all over the country," Smith said.

Smith touched on another lodestone of the Northern Rockies: "Wildlife painting has been and will be a big part of this region's art," Smith said. "Rungius is to wildlife painting what Russell is to historic western painting."

Of course, Russell also found wildlife a favorite subject, a natural enough situation with human life in the region constantly interplayed with wildlife. It is interesting to note that for both Rungius and Russell, wildlife became an integral part of their art — and both chose to settle and work in the region. Remington, always the easterner, did not, and seems to have never developed the love for wildlife of the other two "Rs."

What of these two, who nonetheless became giants of western art? Charles Marion Russell, cowboy artist. Frederic Remington, Ivy Leaguer, consummate depicter of contention for a western empire. Both left indelible marks on understanding of the region.

Remington achieved fame before Russell, and had he not died young — of appendicitis at age forty-eight — he would have built a legacy even more prodigious. As it was, he produced more than 2,700 paintings and drawings and some two dozen bronze sculptures. Many depict, with stark realism, the struggle between white and Indian cultures throughout the entire American West.

Realism was Remington's "just idea," his creed. The finality

22

of life lived close to the edge of survival (or death) throbs in Remington's paintings. Consider, for example, the oil painting he simply titled *Missing*. An Army trooper, captured by Indians, is being led across the prairie, a rope around his neck and his arms bound behind his back. Somber, triumphant warriors ride in single file on either side. There can be no hope for that trooper; only the finality of death for the soldier vanquished.

Another of Remington's often-reproduced works is even more startling in its realism. *Frozen Shepherd* depicts two horsemen in a bitter-cold winter scene coming upon the frozen bodies of a shepherd and his sheep. Caught in a winter storm, they had perished — a not too uncommon incident in the West of that time.

Remington's paintings portray a virile, action-packed West. Unlike Russell, there is little humor in his work. His art is heavy with the romance of challenge, vigor, warfare and finality; yet it is invariably realistic and authentic.

A native of Canton, New York, Remington grew up among

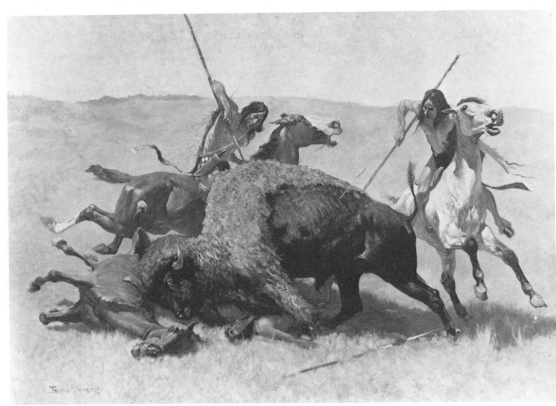

FREDERIC REMINGTON

The Buffalo Hunt

Courtesy:
Buffalo Bill Historical Center
Cody, Wyoming

Eastern gentility. He studied at the Art Students League in New York City and the Yale Art School before going West in 1880 for health reasons. He subsequently had sketches of what he encountered published in *Harper's Weekly* and *Outing* magazine, beginning a career that would give him fame and popularity in his lifetime. Frederic Sackrider Remington would become the friend of President Theodore Roosevelt and achieve his own desire, that of recognition as a fine artist and illustrator.

Fame came to Charles Marion Russell in his lifetime, too, but it took longer for him to achieve heroic proportions. He now is considered the major painter of the American West, and in some portions of the Northern Rockies, particularly his adopted Montana, is referred to in reverent tones. Russell is, for practical purposes, the alter ego of concept Montana — independent, free-ranging, fun-loving, diverse, tolerant and big, meaning big of heart and hope and ambition. His characters betray his own notion that in all men, Indian brave or lonely cowpuncher, there is a sense of nobility and humble joy. The "just idea" for Russell, and the power behind his work, was that he caught the tension of the soul in transition, not just in time. You ache for the people in his paintings and consequently bear the drama of their story. One generation thus passes to another the ethos of its own joys and agonies, triumphs and failures, but more significantly, its hopes.

Russell was born March 19, 1864, in Oak Hill on the outskirts of St. Louis, Missouri, and came to Montana at age sixteen. He might as well have come earlier; his heart was already there, and would remain with his adopted land even in later years when he worked for a time in a studio in Pasadena, California. He died in Great Falls, Montana, on October 24, 1926.

Sculptor Bill Ohrmann of Drummond, Montana, attributes part of Remington and Russell's insight of the West to the fact that they saw it as newcomers. Everything they saw was fresh and needed explanation; not always so with those native to a region. Familiarity dims perception, or clouds its understanding. An example would be the unabashed love Russell held for Indians, while the majority of his contemporaries held convictions just the opposite.

C.M. RUSSELL
Indian Women Moving Camp
Courtesy:
Buffalo Bill Historical Center
Cody, Wyoming

"Most of them (the early artists) were not native-born westerners," Ohrmann said. "It's the way things often work out. A person can see more and appreciate more in a new area. As an example, here in the valley where I live, I'm sure I take the beauty of the area for granted and hardly glance at the mountains around here. But just a short trip to a different area and I notice everything fresh again. I doubt if Russell or Remington would have ever become great artists had they been stuck all their lives on a pig farm. They saw something entirely new and had a great urge to paint it. And of course it was the only way as there were few, if any cameras."

Russell's eye, it seems, must have been photographic. His attention to detail and penchant for accurate illustration of his subject matter are legend. So is his sense of color. From his brush came the muted, warm colors of the high plains and mountain country he traversed and worked in, and obviously loved, particularly the late evenings. Montana takes on a reddish-purple hue in the hour or so before sundown. "Charlie Russell purple" it's called nowadays; it, too, is symptomatic of transition from one time to another.

The strength of Russell's work rests not in his story-telling ability alone, great as that was; he was there, a young cowhand and friend of the Indian. He became more native than

his contemporaries. "I think where Russell and Remington stand, as far as their generation of painters, is that they were actually there and participated in a change in the course of history," painter Marv Enes of Lolo, Montana, said. "Russell, more so than any, actually saw the fencing of the West, saw the changes in society in the West, the effects upon Native Americans, wildlife, and of course, the open-range cowboy. Fortunately, he was there and able to record firsthand these profound effects. He gave us an authentic record of the era."

It is one thing to be in the right place at the right time, and quite another to do something with that opportunity. Russell did so in a manner so grand that his contemporaries, and those who followed him, work in his shadow. A good part of that genius and the legend that has grown up around it was Russell's personality; he plainly was a likeable, even loveable cuss, and out of his kinship with the common man has come a legend that only grows larger with time.

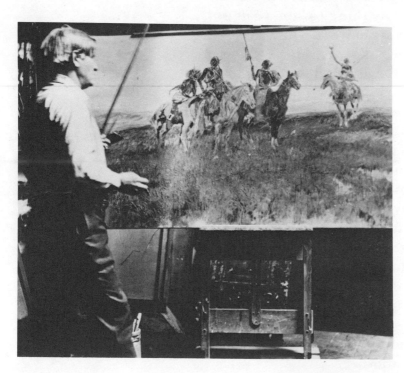

Russell painting at his easel.

Courtesy:
C.M. Russell Museum
Great Falls, Montana

26

chapter three
The Struggle For Identity

THE LENGTH and width of the Remington-Russell shadow has not been entirely good news for many artists painting the same genre. Some have been almost obscured by it; some bask in its covering, and others have broken free to establish their own style and identity.

All painters of western art have been touched by those shadows, whether contemporary to Remington and Russell or subsequent to them. The presence in western art of Russell and Remington is simply too overpowering to ignore.

An obvious question arises: have these two men placed the genre in bondage to them?

One young artist who feels that art of the region is only now coming out from under Russell's shadow is Tucker Smith of Clancy. "Not all of Russell's contributions to the region's art were positive, but because of his great talent and popularity, at least two subsequent generations of artists almost literally copied him. Every painting was judged by the public against his work. Today we seem to be coming out from under the shadow of Russell, and our art will be better because of that."

What of those two "subsequent generations?" It is not likely that either the artists involved or their champions would

TUCKER SMITH
The Hay Sled
Courtesy of the artist

agree unequivocably with Smith's statement, but the general thrust is true. Many works are similar to Russell's. Like it or not, painters and sculptors over the last five decades have been measured against the imposing standard of Russell's work.

All that isn't bad, however. For one thing, it tends to elevate notions of what's good western art and what isn't. Russell set a high standard. The comparison also laid the groundwork for a genuine public interest in art of the region, an opportunity grasped by more than one artist after Russell.

Most noticeable among the latter was the writer-artist and cowboy we know as Will James. James, whose real name was Ernest Dufault, saw his first and greatest work, the book *Smoky,* published the same year Charles Russell died, 1926. It took the nation by storm and subsequently shared in shaping the nation's romance with figures of the American West. Ed Ainsworth, writing in *The Cowboy in Art* suggests that *Smoky* was the beginning of a stampede of public interest in not only the West, but in western art.

Still, it is the Russell shadow that dominates, whoever the

28

artist — never mind that some, and their followers, thought these artists superior to either Russell or Remington.

Edgar Paxson (1852-1919) is an example. Perhaps his most famous work now hangs in the Whitney Gallery in Cody, thanks in large part to the efforts of Dr. Harold McCracken. *Custer's Last Stand* is a monumental work, its story indicative of the neglect Paxson's adopted state (he was born in Buffalo, N.Y.) has shown him, in spite of national attention received during his lifetime.

Custer's Last Stand is six by nine feet and contains more than two hundred figures. Paxson spent nearly twenty years painting it. It was painstakingly researched; undoubtedly it is the most famous of a host of paintings of the Custer encounter. The painting hung for a time in his dining room, then in a dingy corner of a science building at the University of Montana, and finally in the Elk's Temple in Missoula, largely ignored and certainly poorly-treated in the town where it was painted.

Paxson, in spite of the fact that he completed approximately 3,000 canvasses in a career that saw him work out of studios in Deer Lodge, Butte, and Missoula, Montana, has never been able to step out of the shadow that obscured him even in his own lifetime.

Two other Russell-Remington contemporaries, who man-

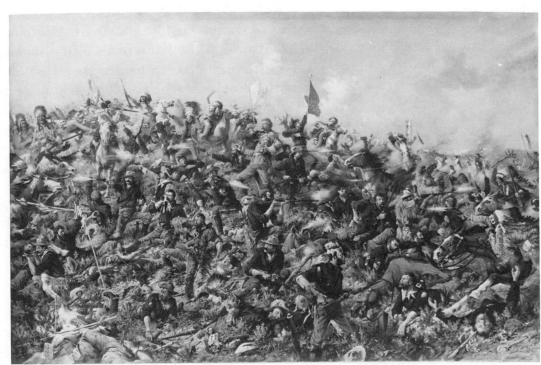

EDGAR PAXSON
Custer's Last Stand
Courtesy
Buffalo Bill Historical Center
Cody, Wyoming

CHARLES SCHREYVOGEL

The Triumph

Courtesy:
Buffalo Bill Historical Center
Cody, Wyoming

aged somewhat better in the public eye, are Charles
Schreyvogel (1861-1912) and Olaf C. Seltzer (1877-1957).

Schreyvogel was befriended by one of the region's authentic American heroes, Colonel William F. "Buffalo Bill" Cody.
Many of his paintings have a distinctively Wyoming air about
them. His relatively brief career, however, was ended tragically when he died of blood poisoning at 51.

Seltzer's work is enjoying a renaissance these days. A native of Denmark, he came to the United States and Great Falls,
Montana, in 1892 to work as an apprentice machinist for the
Great Northern Railroad. He subsequently became friends
with Charles M. Russell. The influence on his work is obvious.
Nonetheless, Seltzer was an accomplished artist in his own
right and the miniature panorama series he did for Dr. Philip
G. Cole of Tarrytown, New York, on transportation, characters of the Old West and historic events are considered classics.

This collection now rests in the Gilcrease Institute of
American History and Art in Tulsa, Oklahoma, and some
forty-six paintings, more than of any other artist, were used to
illustrate the book about the Gilcrease collection, *The Art of
the Old West*.

30

An interesting sidelight to Seltzer's career was his great scheme to portray historic western events on miniature canvases, five by six inches. As he had hoped, they earned him worldwide acclaim. So exacting were these tiny paintings that he had to use a magnifying glass to do them. More than a hundred canvases later he had collectors clamoring for them, but had ruined his eyesight. The double-edged sword cut both ways. He had achieved fame, but at the cost of limiting his working hours for the remainder of his life.

Gerald Peters, in his publication *Classic Western American Paintings* gives insight into the problem Seltzer, or any other artist, has in stacking up against Russell: "Seltzer has never gained the reputation his work merits, partly because he worked in the shadow of Russell, and partly because he did not have the personality to sell himself or his work. He was a shy man who stayed away from publicity and crowds in general, yet became bitter in later years from lack of acknowledgement. Without Russell's colorful, eccentric personality, heralded by all Montana as true-blooded American, and without the freedom of a full-time, life-long career as an artist, the Danish Seltzer did not make the mark upon the art world that he was capable of making."

Many others have followed in the footsteps of these artists. Joe DeYong, a protege of Russell, is one, although he did not stay in the region. Kenneth Ralston of Billings and Shorty

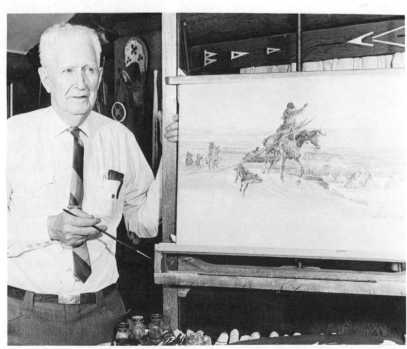

J.K. Ralston
in his studio.

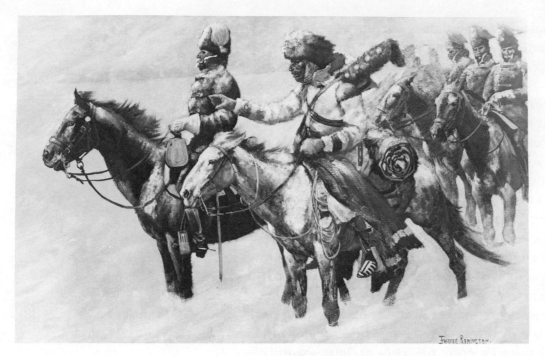

FREDERIC REMINGTON

*Canadian Mounted Police
on A Winter Expedition*

Courtesy:
Amon Carter Museum
Fort Worth, Texas

Shope of Helena did stay. So did Asa L. Powell, who struggled for years for recognition and in a vision perhaps even greater than his predecessors, lived to see accomplished a great personal dream. (See Chapter Four.)

Several reasons combined to make it difficult for these artists following Russell. One was simple economics. Hard times existed, with the Depression, and later the commitment of an entire nation to the war effort in the 1940s. Another was that art simply was not seen in those decades as an expression of life in the region. Even Russell's work hadn't received its full due; that was in the making, across the three or four decades following his death culminating with the publication of two excellent books about him: Dr. Harold McCracken's blockbuster best seller, *The Charles M. Russell Book* in the mid-1950s and Frederic G. Renner's *Charles M. Russell* published in 1966. That same year, McCracken's *The Frederic Remington Book* added to the legends.

Another reason was that art of the entire American West was only beginning to break out of intellectual and economic bondage to the East, where the view was not toward truly American art, but east toward Europe. However, as it had been for settler Russell and visitor Remington, the West they

32

chose to paint gave them all the inspiration and meaning they needed. Their work was not dependent upon other times and places or, for that matter, some standard imposed by critics, who denigrated their subject matter and their work.

The young Montana artist, Joe Boddy, noted both the historic and romantic aspects of early artists of the region. "My feeling is that, unlike Europe or the eastern part of the United States, the West's *first* influences come from fine artists like Remington and Russell, who recorded the West historically and from their hearts. The westerner had little time for decoration or the Art Noveau of the 1900s. He simply wasn't interested in outside influences."

The major reason is one of space and circumstance. There is only so much room at the top; Russell, Remington and Rungius were enough. They had done the definitive work of an era, and the circumstance was that time would have to unfold a new era and a new time so others of a slightly different, if similar, genre could develop.

"They were painting in a time when an end of an era, unique to the world and happening only the West, occurred," Clyde Aspevig of Billings said. "Throughout history, those artists who were fortunate enough to be part of a new movement or get in on a dramatic change in history, became well known because of it." He cited the French impressionists as an example. "Those with more talent, sensitivity, and ability became known as the masters of 'said school' of art. Russell's story-telling, color, composition, etc., were above most of the others and this, along with the subjects he painted, made him the master. He dug into his subjects deeper than most of his contemporaries and generally the public will pick up on those things before they will on lesser artists painting the same thing."

The insight of the public being at the root of an artist's prominence is not without foundation. Dr. Harold McCracken wrote in the 1940s that the professional art world — that of the museums and galleries — lagged behind the public in realizing the significances, and value, of western art.

"There is another reason for the strong upsurge of popular interest in this particular field [western art] of art," McCracken wrote. "It is the old basic fundamental of supply and

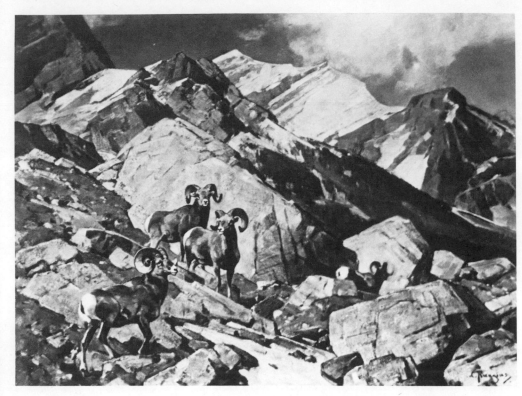

CARL RUNGIUS

*Sheep Country
on the Ghost River*

Courtesy:
Glenbow Museum
Calgary, Alberta

demand, for something which combines idealistic as well as materialistic desirability. In our changed economic times, the small clique of ultra-wealthy art acquirers of past generations have been superseded by a surprisingly rapid increase in collectors of comparatively modest means and considerably more serious in their interest. A good many of our long-established museums have failed to keep up with these changing times, still clinging to the hundred-year-old misconceptions that the only worthy art and the only art of interest to Americans is extrinsic European art. This pedantic irony is, however, not shared by the people generally, and evidence of this fact is overwhelming."

If, in their dominance of the field for two generations, Remington, Russell and Rungius' popularity seems to have tempered the careers of numerous artists, it also has helped make possible the public acceptance of the genre that exists today. They got their just due; others will in time.

"There are many fine western paintings done by equally talented artists, but I think Russell did what Andrew Wyeth has done today," Clyde Aspevig said, "and that was to paint a geographical area from the artist's heart and soul. All the subject matter he needed was right here in Montana. Russell gave today's artist a foundation to build on, and naturally a pride in our state and its heritage."

34

chapter four

Recognition Period

"IF YOU HAVE something to sell, it's best to have a good product," Dr. Harold McCracken told me recently during an interview in his office at the Buffalo Bill Historical Center in Cody.

The venerable McCracken, at 86 the dean of writers about art of the American West, insisted that quality of work is the real foundation on which acceptance of art of the West is based — but that exposure is critical, too. "There are some very fine early western artists whose names are barely known," he said. "Exposure is often the name of the game."

Dr. McCracken offered a parallel with Hollywood, the actors who have good public relations men and get their names on theater marquees are those who command the highest salaries.

Does it follow that all it takes is publicity or public relations? Not at all, Dr. McCracken suggested. The quality of one's work is the basic determinant; from there public acceptance depends, in large measure, on exposure. "There are some artists who don't get anywhere because of lack of exposure," he said.

As an example, McCracken cited Remington's early prominence as *the* artist of the American West. "He was the best known of all the early artists. He was tremendously prolific *and* (McCracken's emphasis) his pictures appeared in the best magazines of the era in large numbers. The basis of the whole thing is how well known an artist is, and it took time for Charlie Russell to win recognition comparable to Remington. It was because he lacked exposure, but once he got it, he received the attention his work deserved."

A footnote to Russell's "exposure" involves the decision by Doubleday to publish McCracken's book on the artist in the 1950s.

McCracken tells it this way: "The editor-in-chief at Doubleday and the managing editor sat in on a meeting with the production manager to discuss my book proposal. The managing editor, who was against publishing the book, demanded to know what it was going to cost to publish this book and how many copies do you plan on printing. The production manager said they'd have to print 15,000 copies and sell 2,350 to come out on the project. 'Who in the hell is going to spend money on a book about an unknown cowboy artist,' the managing editor demanded, but the editor-in-chief said we (Doubleday) needed something to balance a book by Edna Ferber, so my book about Russell got by by a squeak. It was published in late October and by the end of the year all 15,000 copies had been sold."

Charles Russell, and McCracken for that matter, had the exposure, since the book to date has sold more than 300,000 copies. Publication of this ultimately successful book was achieved because he got a break — another factor McCracken believes essential — in this case, to balance other books on the publisher's list.

"Motivation and determination on the part of the maker, and getting the breaks, being able to acquire the exposure, are essential," McCracken said. "Charles M. Russell is an example and so is Bob Scriver (sculptor from Browning, Montana), whose career really took off when he got exposure."

Scriver, of course, had a good product. But he also got a good break in the early 1960s when Dr. McCracken arranged for a show of Scriver's work at the Whitney Galley. "Bob had

36

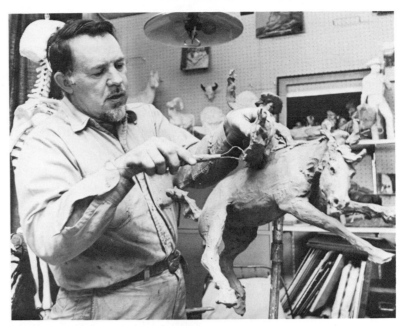

Bob Scriver
in his studio.

been a taxidermist before he'd taken up sculpting, and he
couldn't have had a better basis for understanding his sub-
ject," McCracken said, "but he tried desperately to get his
work displayed. Then I gave him a show in the early Sixties.
We had an example of practically everything he'd done and it
took him three years to fill orders from that one show. He'd
gotten the exposure he needed."

McCracken also cited John Clymer of Jackson Hole,
Wyoming, as an artist whose career has been helped by ex-
posure. "Within ten years, his pictures have gone from hun-
dreds to thousands of dollars," McCracken said. He noted
that Clymer understood better than many artists the need to
actually strive for recognition.

The times have helped. The 1960s and 1970s were decades in
which an artist could — and many did — get exposure
through shows, magazine and newspaper articles, books and,
significantly, word of mouth.

"There was a period of nonexposure for just about every-
body," McCracken said, "and part of that was because so
many of the western artists twenty years ago were copying
Russell."

McCracken also cited a significant trend toward recogni-
tion of Native American artists throughout the entire West.

Recognition is both singular and collective, however.
Across a desert of thirty years without significant recognition
for more than a handful of individuals, art of the Northern

Rockies took on an identity that was tied both to the American West in a general sense and to the region specifically.

Carl Rungius worked throughout this time when, perhaps, it was easier for a wildlife painter to be recognized. His subject matter was specific to the region — elk, mountain goat, bighorn sheep, grizzly; part of the continuing saga of the region and the artist. Whether Rungius or those who followed in his footsteps, wildlife artists could avoid the tag of painting "like" Charlie Russell.

It has been argued that those who painted during the "nonexposure" years of western art did not realize the burden under which they worked, or the contribution they were making to a regional art form.

"I don't believe any of them realized what was going on in the Fifties and Sixties," wildlife artist and sculptor Joe Halko of Great Falls said. "Most were doing what they loved to paint and very few were making a living at it." Clyde Aspevig of Billings agreed. "I don't think any artist really realized what took place in the Sixties," he said. "An artist goes out and paints the things he is most emotionally moved by, hoping of course that he can make a living at it. In the process, he trades ideas with his fellow artists, borrows from past masters, and comes out with his own interpretations. Consequently, much

Clyde Aspevig

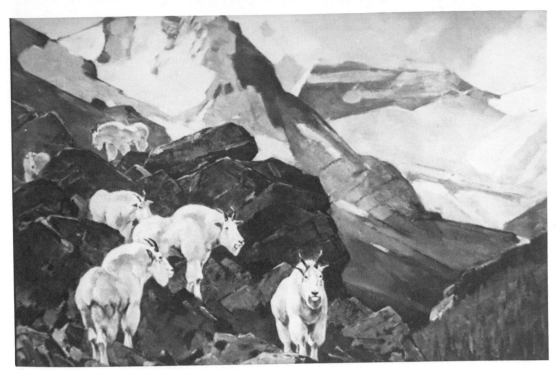

CARL RUNGIUS
Rocky Mountain Goats
Courtesy: Glenbow Museum
Calgary, Alberta

of the art produced over the years, and presently, takes on many of the same characteristics, primarily because they all paint in the same region (landscape) and have the same historical background to study from."

One who did know, however, was Ace Powell.

"Did any of them realize that something as big as what's developed was going on? Ace did! And I am convinced that he had a plan," art collector and dealer Ford Cripe said. "Bob Scriver made a remark that wherever Ace went, all his life, a little art colony grew up. I think from his experiences and frustrations, he perceived that we would not be 'discovered' from the outside, but that the thrust of the Montana or Northwest art movement must come from within. I think this is what did occur."

Asa L. Powell was troubled by an up and down career as a painter, woodcarver, sculptor, and personality of the first magnitude. He was a spellbinder, plagued by alcohol throughout much of his life. It affected both his life and his work, as would the emphysema he suffered in his later years.

In the matter of art, Powell knew the complete spectrum and the points in between. He painted in total obscurity, often trading his work for a drink or a meal; and painted when he was drunk, later dismissing with a laugh what came out. Powell persisted. His name become one of the best known and

most respected in the field. His "Ace of Diamonds" trademark, according to his own estimate, was painted on 12,000 to 15,000 pieces. Powell didn't always keep track during the fog of years when he struggled not only for recognition and a living, but against alcoholism.

Somewhere in the midst of that struggle, in the 1950s, Ace Powell apparently got hold of the vision he would doggedly pursue the rest of his life — recognition of his art and that of others in the region.

"Recognition was the key word in the 1950s," Ford Cripe said. "The few regional professional western artists were seeking not only personal recognition as artists, but recognition that this was even a desirable art form to own and hang in your home. Even a collector was an oddity, and for some years it was customary to borrow 'the paintings' when a building such as a bank or a library was dedicated, to add a little culture to the occasion."

Against this background, Powell, watercolorist Hank Taylor, whose native roots were in Troy, and woodcarver Morris Blake of Hungry Horse, looked to Glacier National Park and its burgeoning tourist traffic as a means of getting outside exposure of their work.

"He and Nancy McLaughlin Powell (Ace's wife at the time; they later divorced) sold their works there, but they seemed to have to compete for sales on a nearly souvenir basis," Cripe

JOE HALKO
The Scout
Courtesy:
Marie's ART-eries
Missoula, Montana

Ace Powell
in his studio.

said. "My sister, for example, has a small watercolor sketch of Ace's with a price still penciled on the back, $1.75. I have a fair-sized pastel portrait that in later years, when I showed it to Ace and said, 'I think I paid you ten dollars for it,' he said, 'No, I was only getting five dollars for them then.' It was original art at barely above souvenir prices."

Cripe began his own odyssey with western art in the early 1940s, trying his hand at being an artist: "Like everyone else, I took a lesson or two and established quickly that I had no talent at all as an artist, and have not been confused since as to what my role was." As a collector and observer of the scene, Cripe's insights provided a perspective few people can match.

"In the early 1950s, recognition from the outside world was fifteen years, and thousands of miles away in Oklahoma, Texas, California and New York, and they (people there) were looking toward and promoting their own," Cripe said. "In other words, the 'outside' would not accept our art on its merit as art until we began buying it in such quantities our selves that it would establish both a shortage and high enough prices to make it respectable."

The "supply and demand" Harold McCracken had referred to in the 1940s had come full circle.

Befriended by Powell, Cripe became both an art dealer and a confidante of artists. "Although I was one of the chosen ones, a creation of Ace's as an art dealer, I was not given the

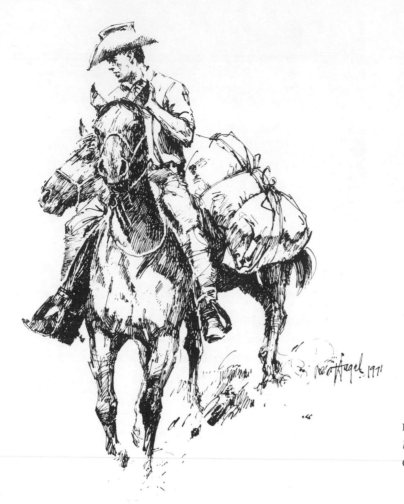

FRANK HAGEL
Untitled sketch
Courtesy of the artist

(Ace's) philosophy in one sitting, but rather bit by bit," Cripe remembers. "It was probably just as well, as I'm not sure that I would have accepted the fact that western regional art would ever reach the plateau it is on today. Ace never doubted that possibility."

Frank D. Hagel of Kalispell, a western painter and sculptor, likened Powell's contribution to that of prophet and standard-bearer. "He really had a lot to do with shaping the whole art movement here in Montana," Hagel said. "His importance can't be exaggerated. He was painting when there was little or no market and had much to do with the creation of markets both locally and in other states."

Powell didn't bear the standard alone, however. In Wyoming another artist worked from the time of Russell to the present. Nick Eggenhofer of Cody, in the minds of many, is

synonymous with the best of the portrayers of the action of the old west.

Bavarian-born Eggenhofer came to the United States at age 16 and settled in the East. He worked with the American Lithographing Company in New York and studied art at the Cooper Union in his off hours. Subsequently, he did illustrations for western pup magazines, his knowledge of the West coming from reading and the study of photographs. He moved to Wyoming from New Jersey in 1961.

His friend and champion in Cody, Dr. McCracken — who, incidentally, mentioned that he had "induced" Eggenhofer to come West — spoke highly of Eggenhofer's efforts to portray everyday life in the West.

"Coming out here got him on the track," McCracken said. "Within two years his work went on a renaissance and last year one of his paintings went for $44,000."

Among others who painted the region and its life during the "nonexposure years," and helped build the region's reputation as a center of fine, interpretive art were Irvin "Shorty" Shope of Helena, and Elizabeth Lochrie of Butte, while Ken Ralston and LeRoy Green of Billings added fine landscapes to the period.

They helped set the stage for what would follow, and perhaps even Ace Powell was surprised.

Irvin "Shorty" Shope

chapter five
A Development Period

FROM HER vantage-point as editor of *Montana, the Magazine of Western History,* from 1966 to 1978, Vivian Paladin of Helena was witness to the drama of art growth in the region — but from a particular perspective. Early in her tenure as editor, a decision was made that would have profound influence on the role the magazine would play in that unfolding drama.

The publication, of course, achieved universal respect and acclaim under Mrs. Paladin's editorship, and a reputation for excellence it still enjoys some two years after her retirement, under the guidance of William Lang. But in the early years of the magazine, amid the embryo days of the area's art boom, attempts were made by some artists or their agents to use the magazine's pages for their own promotion. In short, they contrived to place, or purchase space for, articles about themselves and their work in the magazine.

Vivian Paladin bridled at such attempts. And so did her friend and colleague, Robert F. Morgan, curator of the Montana Historical Society Museum, an artist in his own right, and at that time in charge of layout and design for the

Vivian Paladin

magazine. A basic decision was required or the magazine risked becoming nothing more than a literary prostitute, its pages for hire to the artist who could exert the most influence.

"We decided early-on that the basic mission of the magazine was history, not western art or any other kind of art," Mrs. Paladin said, "and we always tried to have a thread of history running through our articles, though art certainly has had an important role in our magazine."

Indeed it has. Paintings, drawings, old photographs when available — all were used to illustrate articles under the firm policy Mrs. Paladin instituted. She required that those used have a direct bearing on the article involved.

"The increasing use of documentary art in the magazine did not come to me through any great inspiration," Mrs. Paladin said. "No one tapped me on the shoulder and said, 'Hey, use more documentary art.' I did it because when dealing with very early subjects which took place before the day of the camera (and most did), there was no alternative."

Outgrowths of this policy were twofold: she came to know people at major repositories around the country, and she learned how to gather pictures from a variety of sources. The old *Harper's Weekly* drawings were a favorite. "I learned to

45

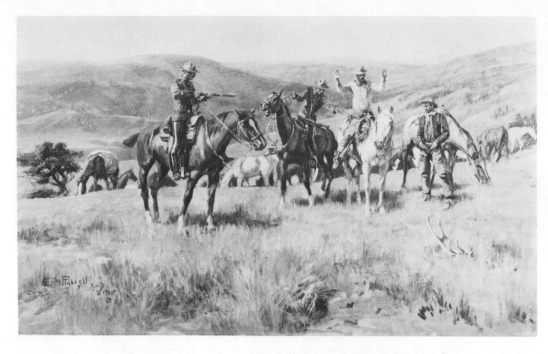

C.M. RUSSELL

*When Law Dulls the
Edge of Chance*

Courtesy:
Buffalo Bill Historical Center
Cody, Wyoming

know the individuals to contact; and in all cases, when the art
was used, it was carefully captioned and credited."

Publication of the magazine by offset printing helped, too,
when initiated in 1964. Before that, Mrs. Paladin recalled, the
old halftone cuts were a terrible barrier to making effective
use of any pictures, including art.

Mrs. Paladin also pursued the historical significance of art
to the region, recalling the counsel of John C. Ewers, author
and ethnologist for the Smithsonian Institution to "seek out
the early artists and do pieces about them." As a result, light
was thrown on the significance of artists like George Catlin,
Karl Bodmer, Dan Muller, Thomas Moran, O.C. Seltzer, Paul
Kane, Winold Reiss, sculptor Cyrus E. Dallin, Lone Wolf (Hart
Merriam Schultz), and Charles M. Russell, among others.

Who would forget, for example, the stunning cover of
Montana, the Magazine of Western History in the summer of 1970
when a "View of the Rocky Mountains" by Karl Bodmer was
run double-truck on the front and back covers alongside a
small color photograph of the same scene taken in 1970; or the
dozens of Charles M. Russell paintings used both on the cover
and inside the magazine. The imaginative and visually-
powerful full-cover "bleeds" of some paintings were striking.

"I think maybe the modern interest in art brought forth
interest in other, lesser-known artists, those who had been
overshadowed by Russell and Remington," Mrs. Paladin said
recently. "I know the interest in artwork in general brought

46

about the use of art on the cover of the magazine."

A spinoff was that the historical significance of art to the region lent credence to contemporary work and the burgeoning public interest in it; in short, one fed off the other.

There were struggles and disappointments, too. Mrs. Paladin, who in a Socratic-like manner disparages her knowledge of art, recalled an incident from the early Sixties that, to her, personified the change that was taking place in art of the region. "The Society had a truly terrible art show hanging in a gallery on the lower level, a gallery now gone. At that time, all of us joined in mailing out the magazine and it was in that area that we did the mailing. Surrounded by mailing sacks and stuffing tables, we were surrounded by walls full of very bad art. Dumb as I was, I knew it was bad art. I no longer know who the artists were — all I know is that a number were represented. One portrait of Theodore Roosevelt, grinning teeth amateurishly outlined and accented in pencil, glared out in my line of vision throughout the mailing process, and I will never forget it. Never, since the 1970s, has art of that caliber been shown in the Society's galleries, and probably not in the region. The improvement since then of available art has been really astonishing."

Since her retirement, Mrs. Paladin has written a number of articles about contemporary artists for *Art West* Magazine, for which she is an editorial consultant. Her assessment is that the art picture has changed for the better almost in direct proportion to its popularity. "I'm not prepared to say why," she added.

Exposure both within the region and outside is one answer; so is competition among artists, and pride. A developing sophistication in both serious collectors and the general public is another answer. As interest in art of the region grew, so did the demand for better work.

One of the turning points was competition in the 1950s for a heroic-size bronze of Charles M. Russell for Statuary Hall in the Capitol Building at Washington, D.C. The national competition was won by a native of Anaconda, Montana, John B. Weaver, a sculptor, and curator at the Montana Historical Society at the time.

Considerable controversy surrounded the selection, which

JOHN WEAVER
Fort Walsh Monument
Courtesy of the artist

Vivian Paladin also recalled with some detail. "When I came to the Historical Society late in 1956, the main order of business was to choose a model of C.M. Russell to be cast in bronze after being 'pointed up' to heroic size. I was very new in town and certainly new to the Society and to art. I do recall, however, that quite a number of sculptors in Montana, and I guess the region, submitted models. Most of them were just awful, and of course, although there was some growling about it, Jack Weaver's was clearly the winner. Among the losers, and he has since told me it deserved it, was Bob Scriver's entry. It was, as he has said, pretty awful. But it spurred Bob on — indeed, the experience made him so aware of how much his great talent needed polishing and perfecting that it actually was a catalyst. I think this incident might be, in microcosm, what has happened to art in the region. There has been a growing, almost palpable improvement. That may be because of the exposure of good art through ever-improving art shows. In other words, people have a chance to see really good art, and their demands have reflected increasing excellence on the part of artists."

An interesting aspect of that competition in the 1950s was that individuals interested in such things had chosen up

sides. Some supported Weaver; others, Scriver; or another favorite. People cared, but few realized the significance the event had for the development of art in the region, and even fewer realized that within a short span Bob Scriver *and* John Weaver would be internationally recognized and honored for their sculpture.

Weaver left the Society in 1961 and for a time was a sculptor for the Smithsonian Institution in Washington, D.C. He then moved to Canada, where he currently works out of a studio in Hope, British Columbia; he became a Canadian citizen in 1972. Weaver won several major competition awards in recent years, including the International Competition Award for *Kootenai Camp Life,* a ten-foot by twenty-foot bronze relief located in the Interior Orientation Gallery area of the Treaty Tower at Libby Dam, Libby, Montana.

Another major award of Weaver's was a National Competition Award (in Canada) for *Prairie Encounter,* a one-half life-size double equestrian monument dedicated at Fort Walsh, Saskatchewan, to honor the first arrival of the Northwest Mounted Police at Fort Walsh. His eight-foot monument *Bullwhacker* is exhibited in a pedestrian mall at Helena; it won an International Award Competition in 1976-1977. Weaver also won an International Award Competition for *Virginia City Relief* at the Madison County Courthouse in Virginia City, Montana; it depicts settlement of that gold rush town.

That 1956 contest for a Russell bronze actually launched Scriver's career as a sculptor. A taxidermist, he put together a model statue in nine days to compete in the selection process. It lost to Weaver's model, but Scriver was undaunted and set out to hone his skills. Today many consider him among the best sculptors in the world.

Scriver's major works include a heroic statue of the late William E. "Bill" Linderman for the Cowboy Hall of Fame in Oklahoma City, an awesome Rodeo Series about which he did a book called *An Honest Try,* and his beautiful piece in Fort Benton, Montana, commemorating the Lewis and Clark Expedition.

Scriver began sculpture at age 46. Today, at 66, a scant twenty years later, he has received honors from the Cowboy Artists of America and the National Academy of Western Art

JOHN WEAVER
The Bullwhacker
Courtesy of the artist

— and is a member of both groups. He also is an elected member of the National Sculpture Society, the Salamagundi Club, Society of Animal Artists and the International Art Guild.

June 3, 1972 was proclaimed "Bob Scriver Day" by the State of Montana in conjunction with the first showing of his famed rodeo series at the Montana Historical Society Museum in Helena. He also had a big show in 1969 at the Whitney Gallery of Western Art in Cody, prompting Dr. Harold McCracken, then director of the gallery, to call Scriver "the foremost sculptor in America today — bar none."

If Weaver and Scriver exemplify that drive toward improvement and excellence generated in the fifties, sixties, and seventies, they were not alone in their "brush with the west."

"It wasn't just in art that we saw a phenomenal increase in interest in the West and particularly in this part of it," John R. Brice said. "It was happening with everything. Literature, land, space, wilderness, recreation, coal. People came in and bought up things at a time when they couldn't believe they'd do something like that."

A considerable influx of new creative people to the region was also involved. Some were artists and some more would-be artists; it would take time, in some cases, to distinguish the difference.

Up to the 1950s and 1960s, as Joe Halko noted, artists had come from the East only to gain subject material. "Then

Bob Scriver working on Linderman sculpture.

RON JENKINS
Woodduck
Courtesy:
Marie's ART-eries
Missoula, Montana

they'd go back East to make a living, and the few who stayed year-around made a very poor living."

The crux was that more and more stayed each year; or at least were *able* to stay. The market, and the potential to make a living in the region, grew right along with public interest in the art of the area. Yet almost always the artists had to look outside the region for markets to supplement what they earned from sales within it.

An example is wildlife artist Ron Jenkins of Missoula, who came to Montana in 1968 from Pennsylvania. In 1965, Jenkins' painting of canvasbacks was chosen from among 200 entries as winner of the coveted Federal Duck Stamp Design Contest, and he had struggled since to "make it" as a wildlife artist. His decision to quit a comfortable job in the East and launch a career as an artist in Montana was typical of what was going on in the region. A good number of similar-minded explorers made the same decision about the same time; it just happens that some were artists, some doctors and dentists and hikers and fisherman, or what-have-you. The region appealed to them.

"Montana natives don't realize the mystique of the area as do people from more populated areas," Jenkins said. "The art that is produced here, that which shows off the beauty and the landmarks, often identifies us as part of the region —

51

JOE HALKO

Spooked

Courtesy:
Colonel and Mrs. Tom Coblentz

someone lucky enough to be able to live here and easily go to these special places of beauty, and see such things as eagles, grizzly bears, water so clear you can actually see the bottom, and catch fish." He paused a moment. "Actually, I think we're just showing off. People normally associate you with your environment."

Halko suggested that the appeal of the Northern Rockies is that much of the region hasn't yet been trampled by modern society. "Some still remains for artists to observe so they can paint or sculpt," Halko said. "Some isolated areas have not moved much farther than when Russell observed them; thus they (artists) become inspired to put it down on canvas or into bronze."

John Brice agreed. "The region already has achieved its identity," he said. "Artists react to the place they're painting, and the number of artists here helped accelerate the notion of that complete identity."

Frank Hagel of Kalispell is a native of the region who was working outside it, but came back in 1972 to go full time as a painter and sculptor of the modern-day scene in Montana. A particular interest to him is the whole subject of outfitting and horse packing in the region's wilderness areas; many of his canvases reflect an emotional involvement with that activity. Although a native, he is convinced that transplants like Jenkins develop uncommon sensitivities and loyalties to the region.

"This is art of a regional nature we're seeing," Hagel says. "It has little or nothing to do with the art of the Southwest, whose roots are in the Taos School of painting. It is mainly practiced (at least successfully) by artists who have an innate love of this region, particularly those who are so attached emotionally that they'd have a hard time functioning as fine artists elsewhere. In many cases, these are people who are transplanted citizens of the area, just as Charlie Russell was."

He cited several examples: Wildlife artist Tom Sander and his wife, Sherrie; and Bill Jasper and Fred Fellows, the magnificently successful western painter-sculptor. Others come to mind: James Bama at Wapiti, Wyoming; Gary Carter and sculptor Pat Mathiesen at West Yellowstone; John Clymer at Teton Village; and sculptor Michael Dedmore, now of Victor, Montana, but formerly of Billings.

"These people are primarily interested in portraying this area they love and it shows in their work," Hagel said. "Tom Sander's flat gray light, for instance, which is reminiscent of the Flathead. But my point is: good western art is regional art. We still have a few competent eastern artists who will come out hoping to cash in on this phenomenon and, for some reasons they can't fathom, never really make it. Their work is hollow because they look at this country, can do a fair job of

Frank Hagel
Courtesy of the artist

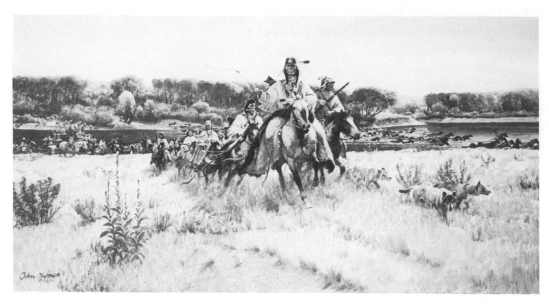

JOHN CLYMER
Nez Perce
Crossing the Yellowstone
Courtesy of the artist

copying the face of it (be it people or landscape), but never really *feel* it."

It is Hagel's contention that this feeling, the emotional attachment, gives understanding that shows up in the artist's work. He cites John Clymer of Teton Village, Wyoming, as an example. "When he paints a mountain man out in the snow, it feels cold. This is because John has deep roots in this area and knows what this region is all about and what cold feels like. And it shows, in fact comes shining through, in his work."

Hagel *and* Clymer have similar roots in the region. Each was born within it, Hagel at Kalispell in 1933 and Clymer at Ellensburg, Washington, in 1907. Each left the area to pursue a career in commercial art; quite independent of the other, each responded to an internal call to return home and paint. And both have received widespread recognition for their realistic interpretation of that homeland.

Wildlife painter Elmer Sprunger of Bigfork, Montana, is another whose roots are in the region. But unlike Hagel or Clymer, Jenkins, Carter or others who returned to or came to the area with the art movement in full force, Sprunger is the ideal example of those few artists who were part and parcel of it from ground zero. He is both child and maker of the region's growth as an art center.

54

Sprunger was born within a few miles of where he now lives in a home-studio he built in Bigfork, a picturesque little community on the northeast shore of Flathead Lake in northwestern Montana. He has become best known and honored for his exquisitely rendered oil paintings of elk and buffalo, as well as smaller animals like the chipmunk, marmot, beaver and numerous bird species.

Like many who become artists, Sprunger's talent showed up at a young age — but situations of life, such as a war that took him to the Pacific and subsequent jobs as laborer, carpenter, logger, and sign painter, dominated his life. He began painting wildlife regularly in the early 1960s; acceptance and acclaim followed and by the end of the decade, he was ready to make the big leap. He became a full-time artist.

Wildlife is to him the essence of the region's spirit, its meaning. It symbolizes something he says is found all too seldom in man: freedom, integrity, unpretentious regality, consistency. Wildness, naturalness. "Animals in the woods aren't slaves to man," he said. "They show this in the way they walk, their reactions to their environment and changes in it. They're free and they portray this, in sharp contrast to the way domesticated animals portray their captivity, their loss of selfness, freedom."

Sprunger's canvases pulse with this freedom. His style is very detailed and realistic. The wildlife never seems separate

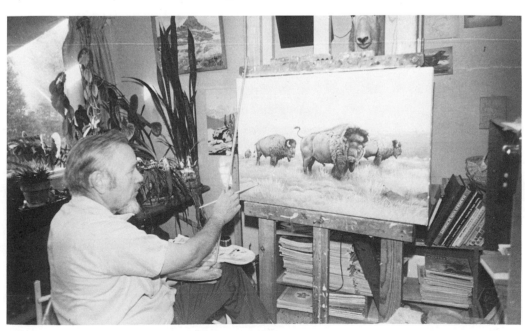

Elmer Sprunger
at his easel.

Courtesy:
Ruth Steel
Bigfork, Montana

ELMER SPRUNGER
Buffalo
Courtesy of the artist

— to lift out of the setting in which his artist's eye places them. "Wildlife seems to be one of the few enduring things in this day when we have so much planned obsolescense," he says. "Wildlife paintings in turn have an ongoing value to them, a continuity of time, a timelessness. An elk today is very much like an elk was a thousand years ago, and yet we may be right at the moment in time when many forms of wildlife will disappear just like that. Maybe that's what most of us doing wildlife paintings are trying to say."

The point is that Sprunger conveys, on his canvases and in his words, that feeling Hagel says is so fundamental to art of the region. He and others who shared in making the region's reputation as a center of art did so, not because they tried to accomplish something, but because what inspired and motivated them was already there. What needed expressing was the caring, the love and kinship; and it is those qualities which give Sprunger's art and other sensitive art of the region its integrity. It is the same caring and kinship that gave credence to the works of Bodmer and Russell, and to the pages of Vivian Paladin's *Montana, the Magazine of Western History.* Each spoke for itself, enhancing the other; it is part of a whole only now being understood.

chapter six
The Outside Threat

NOTHING GALVANIZES an issue or brings it to sharp
focus like taking from somebody something they believe is
rightfully theirs. Never mind that it isn't theirs, in a legal
sense. The *idea* of possession is what really counts. Take it and
you evoke outrage and anguish you never dreamed existed.

Just that happened in Montana in the early 1950s. The
collection of Charles M. Russell's paintings known as the
"Mint Collection" was sold to out-of-state interests and taken
from the state. It was an imagined and, to some, a real
tragedy, still felt in Montana, but it had its good effects.

Nothing could have done as much in one moment to elevate
Montanans' consciousness toward art and its significance.
That Texan used mere money to literally steal our Charlie
Russell paintings. *Our* paintings! *Our* Charlie Russell! It's an
outrage! Plunder! The state was disgraced. And so the
dialogue went in Montana for a good number of years follow-
ing the Mint Collection sale in 1952 to the late Amon G. Carter
of Fort Worth, Texas, through an intermediary, the Knoedler
Gallery of New York City.

Amon Carter, perhaps unwittingly, kindled fires in Mon-

C.M. RUSSELL

Wild Horse Hunters

Courtesy:
Amon Carter Museum
Fort Worth, Texas

tana that fanned into flames overnight, helped, in part, by the keen strategy of a man who wasn't about to let Montanans forget the ample opportunity to keep Sid Willis' Mint Collection in Montana. K. Ross Toole, then director of the Montana Historical Society, was both angered and distraught that Montana was unable to raise a mere $125,000 over a four-year period, 1948-1952, to buy the collection. Indeed, only $13,000 had been achieved toward that figure.

The collection subsequently was sold to Carter for $165,000; today its value is in the three million dollar range.

Toole took advantage of theh loss of the Mint Collection to goad Montanans' pride. An opportunity came from the state to acquire the Mackay Collection of Russell art; Toole had to raise $50,000 in four months, and with the help of many others, did it largely by making Montanans realize what they had lost by letting the Mint Collection leave the state. He initiated a massive, high-geared fund raising campaign, which got offensive in both meanings of that word. "We set up a speaker's bureau to go around to any audience available and say, in effect, 'Shame on you for letting Texas steal our Russells,' " Toole admitted to author Paul T. DeVore, whose excellent article on the Mint Collection appeared in the Autumn 1977 issue of *Montana, the Magazine of Western History*.

One paragraph from DeVore's article tells much of the

story, and the sentiment involved: "Whether one seriously considers the explicit pictures or not, the truth is that Montana 'missed the boat' in not retaining Sid Willis' painstakingly gathered collection. Nevertheless, as has been pointed out, its loss had a silver lining. A case in point: The $12,000 to $13,000 raised in the 1948-52 campaign was finally used by the Montana Historical Society to give initial support for its purchase of the famous Malcolm S. Mackay collection of Russell art. Under the leadership of Dr. K. Ross Toole, then director of the Society and now a professor of western history at the University of Montana, an additional $50,000 was raised in about four months. In the opinion of many, this collection has a market value of better than $2,000,000."

Why had the drive to buy one collection been such an abject failure when the other, for less money, succeeded?

For one thing, the campaign to get funds for the Mint Collection had been without either focus or intensity. Further, there simply was not a general appreciation for Russell and his art at that time. Loss of the Mint Collection, and Toole's flame-tinged rhetoric, helped change that, but until the people of Montana realized that Russell's works might not always be in the state, apathy was the rule.

Amon Carter, Sr.
Courtesy:
Amon Carter Museum
Fort Worth, Texas

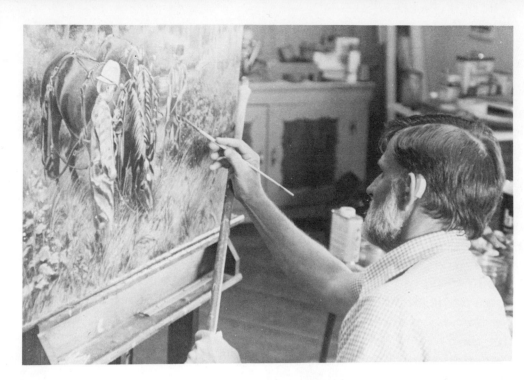

Bob Morgan
at his easel.

Bob Morgan of Helena, just beginning his career with the Montana Historical Society at that time, was a witness to much of what went on regarding both the Mint and Mackay collections.

"The Mint sale really woke people up, and Ross Toole never let them forget it," Morgan says. "Montana was losing not only its Russells, but a lot of other things too. All of us began to get a sense of our historical bearings, and Russell's works are so fundamental to that."

Another who would not let Montanans, and westerners in general, forget that they were losing "priceless pieces and collections of western art to eastern markets and private collectors" was a man who played a part in the Mint Collection leaving Montana, Dr. Harold McCracken. At the time, he lived in New York, but subsequently moved to Cody, to establish the Whitney Gallery of Western Art.

In 1960, after coming to Wyoming, McCracken was in Billings, Montana, and in an interview with the *Billings Gazette* politely chewed out Montana citizens for letting the Mint Collection "slip away."

McCracken's role in the Mint sale to Carter happened this way: He was working in New York and one day received a call from one of the owners of the Knoedler Galleries, which was handling the sale of the Russell collection. "We've got something you'd be interested in," he was told.

60

At the galley, McCracken recognized the Mint Collection at once, but was cautioned to keep silent about it. "I was told the paintings had left the state in secret and that, outside of the gallery owners, I was the only one who knew," McCracken said. He asked and was given permission to call Carter, the wealthy Fort Worth art collector whom McCracken had purchased art for in the past.

"I finally reached him by phone at his home about three o'clock the next morning, and when he learned what was involved, he caught a plane and arrived in New York shortly after noon that same day." Three hours later, Carter and the gallery agreed on a price.

McCracken was quoted by the *Gazette* in the 1960 story as saying that, as long as the collection did leave Montana, he was glad it had gone to a man who planned to build an art center to display it, and other parts of his collection, to the general public.

"That collection could have stayed here [in Montana]. The people of Montana could have gotten it so cheaply," McCracken said. "Please, don't think I'm rubbing it in. I'm not — but you know, we have some things at the Cody museum that also should have stayed here."

The rest of the *Gazette* story is pure McCracken, straight from the hip. It's worth quoting directly: "There is a lesson,

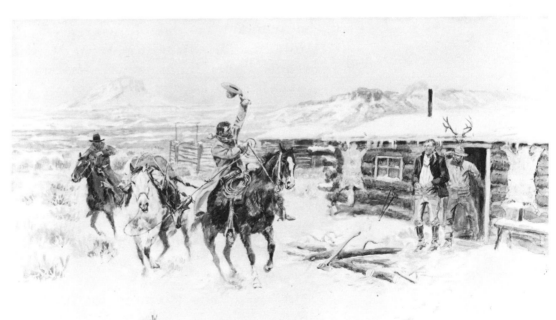

C.M. RUSSELL

Christmas at the Line Camp

Courtesy:
Amon Carter Museum
Fort Worth, Texas

McCracken admitted, in this story. 'I hope, sincerely, you folks will take a moral from it,' he said. 'We're so close to these things, these treasures of our West that are so worth preserving, that we can't realize what they represent.' He smiled warmly. It's the old adage, he agreed, about being so close to the forest that one can't see the trees. 'Then one day,' he said, 'you look for the shade — and the trees are gone.' "

Vivian Paladin made this observation: "Trends in so many things seem to hit here later than they do in other places. Even our gold rush followed after the placer bonanzas were over in California, Nevada and even Idaho!" she said. "In the 1940s, the worth of C.M. Russell's art was better known in New York and Texas and other places than it was in Montana. Good old Charlie was remembered and beloved by many who knew he was pretty expert with a ball of clay in his pocket or a paint brush in his hand. But there was not enough real appreciation of his art to get Montana busy in time to save many collections from leaving here. The fact that the Montana legislature, a couple of years ago, appropriated $100,000 to save one painting, *When the Land Belonged to God,* is a commentary on this. The entire Mint Collection could have been had for much less than that in 1940, or in the decade of the 1940s. Ross Toole had one dickens of a time raising the money in 1952 for the entire Mackay Collection. And so it goes."

About this same time, other things were happening which contributed to public awareness of, and support for, Montana's artistic heritage. The Montana Historical Society opened its new building in Helena; shows followed not only of Russell's works but contemporary artists as well. People came by the thousands to see them.

A fellow named Dick Flood, one of the first to fully realize what was going on, for years quietly gathered up the works of many regional artists — contemporary and deceased alike. He subsequently opened Trailside Gallery in Jackson Hole, Wyoming, and because he was in on the ground floor of the regional art business became somewhat of a legend himself. His venture was a success and other galleries began to open throughout the region. Flood now lives in retirement at Mesa, Arizona.

In Great Falls, Montana, the Trigg Gallery expanded and

Interior
Whitney Gallery
of Western Art
Cody, Wyoming

the Charles M. Russell Museum was built, the C.M. Russell auction was conceived (see Chapter Ten) and it has been of great significance to contemporary art.

In Cody, the Whitney Gallery of Western Art opened on April 25, 1959. Costing $400,000, the building represented the last word in gallery construction. The main gallery was 240 feet long, with walls paneled in redwood and with terrazzo flooring. When opened, it contained an estimated $3,000,000 worth of paintings, bronzes, Indian artifacts and memorabilia.

With optimism befitting the enthusiasm he still exhibits today, Dr. McCracken said at the opening, "its exhibits would do justice to New York City or any other metropolitan center."

It would do so today, too. At its dedication in 1959, attention was paid the fact that among its collections were more than 100 Frederic Remington original bronzes and paintings. Included was his painting, *The Prospectors,* then valued at $45,000. Yet even that fine painting pales alongside the one now displayed behind thick plexiglass on a wall just outside the door of Dr. McCracken's office on the main floor of the gallery. It is Remington's *Downing the Nigh Leader,* which the venerable McCracken termed the artist's "finest and most famous painting."

This outstanding work was reproduced as a full-page, full-color illustration in *Collier's Weekly* on April 20, 1907. McCracken explained that when an art dealer first bought

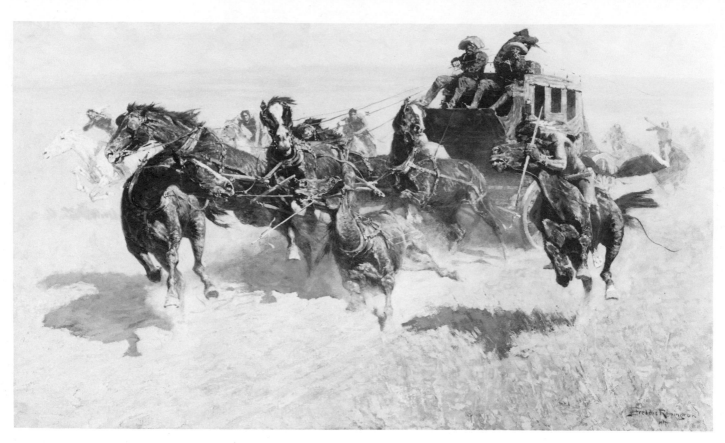

FREDERIC REMINGTON *Downing the Nigh Leader*
Courtesy: Buffalo Bill Historical Center, Cody, Wyoming

the painting from Remington, the artist got less than a thousand dollars for it. The painting was sold to Lincoln Ellsworth of New York City, who kept it in his home until 1979 when Ellsworth's widow accepted a record offer for the painting. How much was the record offer? *One million dollars,* Dr. McCracken said.

As significant as the price is the willingness of the painting's new owner, who wishes anonymity, to place the Remington masterpiece on public exhibition in the Whitney Gallery — fully seventy-three years after Remington painted it. Significant, too, is the new owner's choice of where to display it, within hailing distance of the Big Horn Basin, which McCracken believes is the setting of the scene.

In Canada, the marvelous Glenbow-Alberta Institute in Calgary houses not only an outstanding fine arts exhibit in its new building, but also historical and cultural exhibits, a library, military and mineralogical collections, photographic archives and a modern photographic laboratory.

64

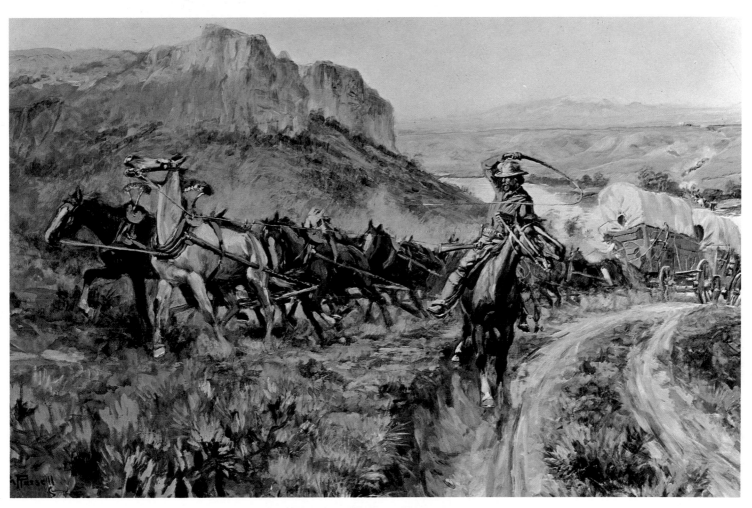

Plate 1. C.M. RUSSELL *The Jerkline*
Courtesy: C.M. Russell Museum, Great Falls, Montana

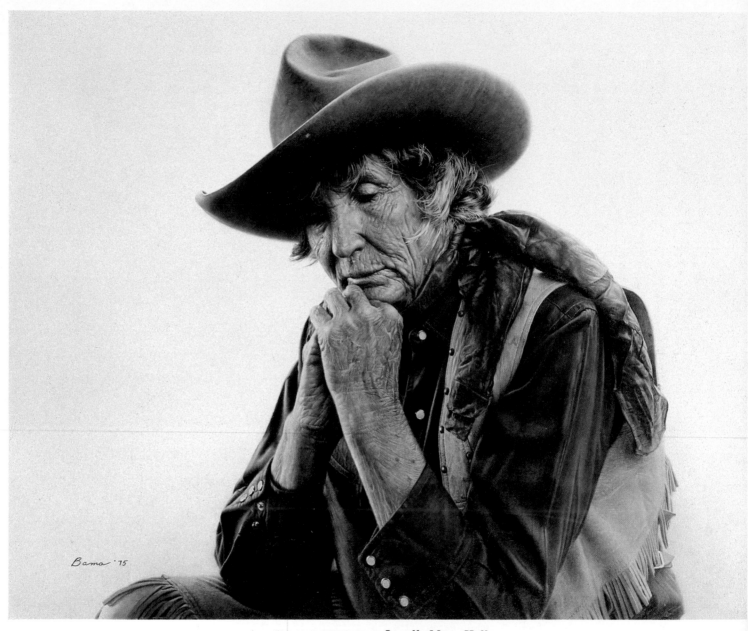

Plate 2. JIM BAMA *Lucylle Moon Hall*
Courtesy of the artist

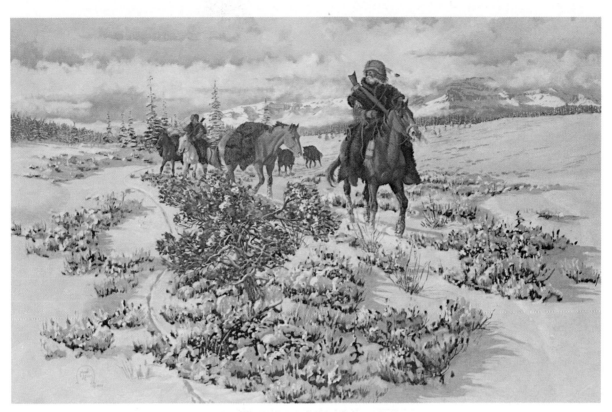

Plate 3. MARV ENES *Men of the Madison*
Courtesy: The Vick Gallery, Missoula, Montana

Plate 4.

JACK LOGOZZO
The Elk Hunter
Courtesy:
Marie's ART-eries
Missoula, Montana

passed, now,
is the day
when the eagle
spoke...

and the Great Mystery
listened...

And the buffalo
walked... near to where the People hungered
 in dignity
 and in deep belief.

Plate 5. JACK HINES *When the Eagle Spoke*
Courtesy: Mill Pond Press, Venice, Florida

Plate 6. ROBERT NEAVES *White Cloud; Mulies*
Courtesy: U.S.D.A., Forest Service

Plate 7. M.L. COLEMAN *Illusive Mountain*
Courtesy of the artist

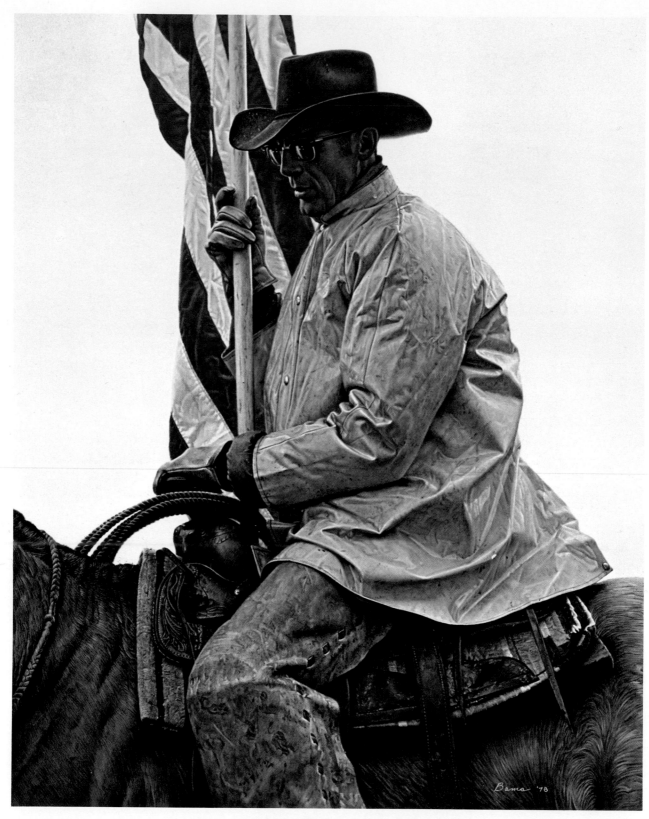

Plate 8. JIM BAMA *Waiting For the Grand Entry*
Courtesy of the artist

Plate 9.

M.C. POULSEN
Chuck Poulsen, Outfitter, 1925-1977
Courtesy of the artist

Plate 10. M.C. POULSEN *Wrangler in Yellow Slicker*
Courtesy of the artist

Plate 11. CLYDE ASPEVIG *The South Hills*
Courtesy of the artist

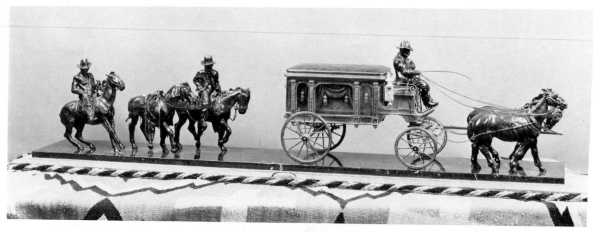

Plate 12. BUCKEYE BLAKE & GIL MELTON *The Rainbow Trail: The Funeral of C.M. Russell*
Courtesy of the artist

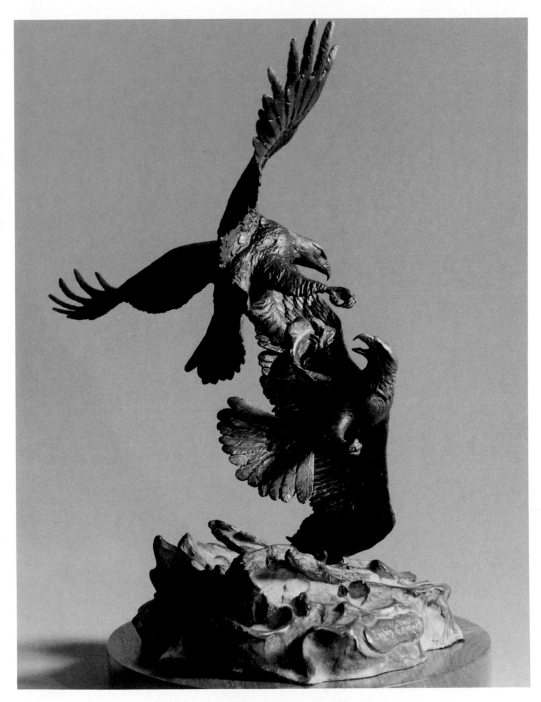

Plate 13. CLARK BRONSON *Eagle's Conquest*
Courtesy of the artist

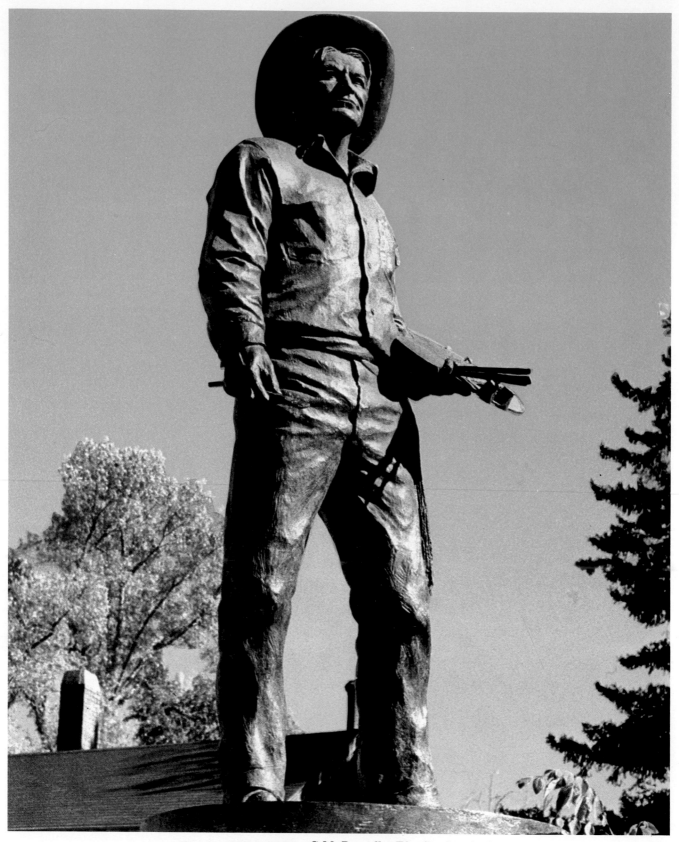

Plate 14. BOB SCRIVER *C.M. Russell – The Cowboy Artist*
Courtesy: C.M. Russell Museum, Great Falls, Montana

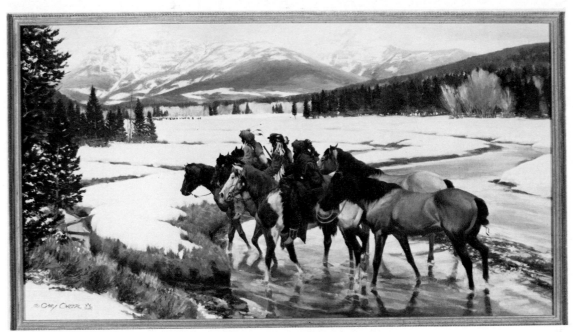

Plate 15. GARY CARTER *Buffalo Runners*
Courtesy of the artist

Plate 16.

VERYL GOODNIGHT

Elk Mountain Burn
Courtesy of the artist

Plate 17.

RON JENKINS

Canada Geese

Courtesy:
Marie's ART-eries
Missoula, Montana

Plate 18.

BOB WOLF

*Wings of Summer
(Red-Tailed Hawk)*

Courtesy of the artist

Plate 19. JOE HALKO *Memories of a Lifetime*
Courtesy: Colonel & Mrs. Tom Coblentz

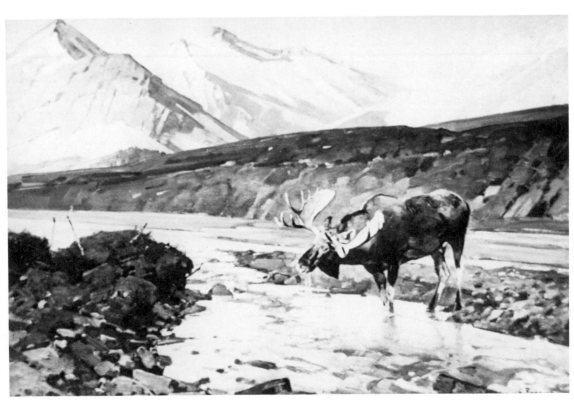

Plate 20. CARL RUNGIUS *Morning on the Ram*
Courtesy: Glenbow Museum, Calgary, Alberta

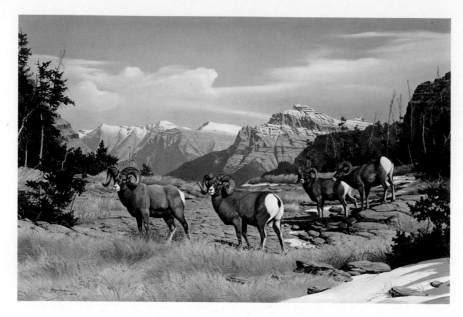

Plate 21.

ELMER SPRUNGER
Rams at Logan Pass
Courtesy of the artist

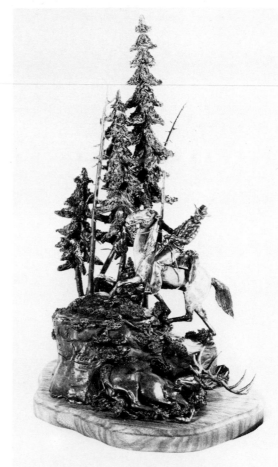

Plate 22.

RON HERON
Camp Meat
Courtesy:
Marie's ART-eries
Missoula, Montana

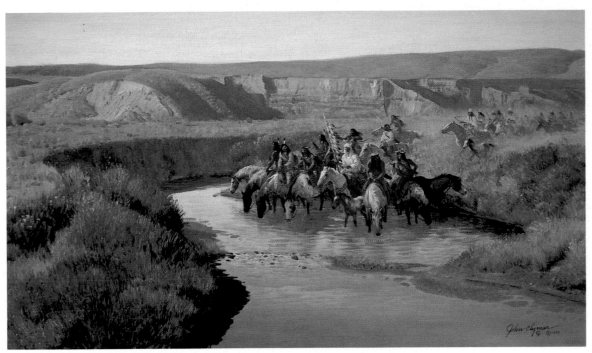

Plate 23. JOHN CLYMER *Cayuse on the Touchet*
Courtesy of the artist

Plate 24.

HUGH HOCKADAY:
Artist with some
of his portraits

Plate 25.

BILL OHRMANN

Spurring High

Courtesy:
Marie's ARΓ-eries
Missoula, Montana

This institute got its start in the 1950s at about the same time Montanans were losing the Mint Collection. Wealthy oilman Eric L. Harvie incorporated the Glenbow Foundation in 1954. In turn, the Legislative Assembly of the Province of Alberta incorporated the Glenbow-Alberta Institute in 1966; among other things, its purpose was to bring together the legacy of Eric L. Harvie and his family, the collections of the Glenbow Foundation and the Luxton Museum in Banff.

The collections include fine arts, but rare books, documents, old maps, Indian artifacts, paraphenalia from early white settlements and activities in the region, military equipment and other items as well. A particularly prized possession is that record compiled by Philip Maximilian, Prince of Wied-Neuwied, and artist Karl Bodmer on their Upper Missouri River expedition of 1833-34.

Collectors, and the notion of collecting, both take from and give to specific regions, however. The Mackay Collection previously mentioned is an excellent example. It stayed in Montana basically because of the generosity and sense of historic place of one man — Malcolm S. Mackay, Jr., of Long Lake, Minnesota, and Roscoe, Montana — coupled with the efforts of those who contributed to raising additional funds to acquire the collection for the state and people of Montana.

"The Mackay family literally gave that collection to the state," Bob Morgan said recently. "There's no way we could have afforded what it was really worth."

In 1972, Mackay was named honorary chairman of the first Rendezvous of Western Art held in Helena, and sponsored by the Montana Historical Society. He wrote about the Russell collection in a publication about the Rendezvous, explaining the family's desire in the Forties to place his late father's Russell paintings on public display. At first they were shown in the lobby of the Northern Hotel in Billings.

"A few years later, when the Mint Bar collection in Great Falls was sold, ours became the only important collection of Charlie Russell's work left in the state," Mackay wrote. "It seemed imperative that we do something at once to assure that it be kept intact and remain here in Montana. My mother, who was really the key person in all of these decisions, was in full and complete agreement, and as many of you already

Malcolm Mackay, Jr.

know, the Mackay collection of paintings, drawings, illustrated letters and bronzes was turned over to the Montana Historical Society, where it can be enjoyed by those many thousands of western art lovers who come to the state in growing numbers from all over the country."

However, the problems of acquisitions are never-ending. The Historical Society and other groups periodically attempt to raise funds to acquire more of Russell's art, and that of other artists.

chapter seven
The Awareness Comes Alive

A NEW BREED of artists has emerged in the Northern Rockies. They are young, confident, outspoken, educated, and not afraid to tell you they're learning; they expect their work to develop, to change. They've been around, and know struggle, commitment, and frustration. Significantly, they've made the difficult choice to pursue their careers as artists today in the Northern Rockies; this is what they want to paint, and where they want to paint.

"There are a variety of reasons why artists have developed and gathered here," John Brice said, "including the number of galleries, outlets, auctions and other activities taking place. There is appreciation for the area that the people here share, and artists appreciate being around people who love the land, people who support their endeavors. That makes for a likely audience for their work; they reinforce each other." There is perspective, too. Consider a statement by James Bama of Wapiti, Wyoming, who left a lucrative career as a commercial illustrator in New York to come to Wyoming in 1968 and commit himself full-time as a fine artist in 1971.

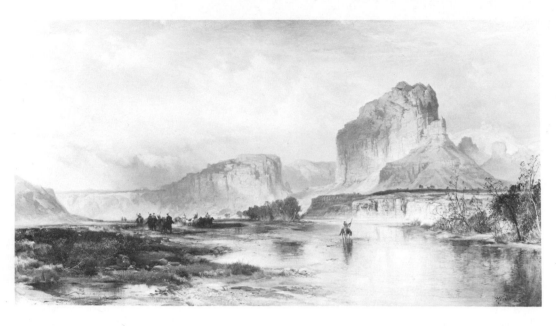

THOMAS MORAN

Cliffs of Green River

Courtesy:
Amon Carter Museum
Fort Worth, Texas

"What excites me is sometimes taken for granted by artists who were born in the West," he wrote in 1973 in an article about his art in *North Light*. Bama doesn't consider himself a western artist, though many of his paintings are of western themes.

"But what a wonderful source of inspiration and material I have found — to say what I want to say about life and work and what I believe in," Bama wrote. "Out here you see the remains of the early settlers; their cabins, saddles, and other artifacts. There are people still living older than the state of Wyoming. One is made more aware of the sad fate of the Indians, and of the changes taking place out here even now: the developers and retired easterners, the tourist business, and other forms of 'progress.' The rape of the Old West is here, but there is still a chance to capture some of what once was."

A close friend of Bama's and a fine young artist, M.C. "Mike" Poulsen of Cody is just as insistent about painting what he sees as his niche in western art.

"I'm honestly trying to portray the West of today," Poulsen said recently in his Cody studio-home.

Outfitters and their lifestyles are what Poulsen knows and wants to paint. At 28, he has a dream and it goes something like this: it is the Twenty-first Century and a visitor at the

68

Buffalo Bill Historical Center in Cody is looking at a painting, an M.C. Poulsen painting, and says, "That's a Poulsen. He painted outfitters from the 1960s to 2030."

Poulsen uses the word "niche" a lot when he talks about his art. The dictionary defines niche as "a person's place or position" and Poulsen, like many younger artists working today, insists that his niche is unique. "Painters look for identity and a place to paint. I felt obligated to portray the part of the West I know, including the part that is vanishing, and its tragedies."

The word tragedy somehow holds special meaning and you point to the exquisitely-rendered portrait hanging on the wall of his studio. It is of a denim-clad, mustachioed westerner of today with a white-handled sixshooter on his side. You remember seeing the painting in the Poulsen brochure you picked up at the Buffalo Bill Historical Center. It is a sensitive, loving portrait, *Chuck Poulsen, Outfitter 1925-1977*. My eyes met those of young Mike Poulsen in a wordless question.

"My father — he was killed in a hunting accident in 1977. November 7th," Mike said quietly. "Really, it's the world he gave me, his world, that I'm trying to portray in my work, the cowboy of today."

Jim Bama
Courtesy of the artist

JIM BAMA
*Chuck Wagon
In Snow*
Courtesy of the artist

M.C. Poulsen
at his easel.

Gary Carter
at home.

That is precisely the kind of feeling another outfitter-painter, Frank Hagel, suggested has given the region's art its special identity and meaning.

"Yes, we can achieve a regional identity," Tucker Smith of Clancy, Montana, said. "This area itself is unique. Historically, it has been populated by individualists. And I feel there isn't an alternative. We will have our own art."

Some are convinced it already has been achieved. Gary Carter of West Yellowstone is one of those. "The region cannot help but achieve its identity — it already has it," he said. "Potentially we have more natural beauty and water. People and artists who live here are outdoor-oriented and apparently prefer art that reflects their own regional fantasies. This area is so vastly different from the Southwest. I lived in Arizona and visited this area long before I could afford to move here." Then he added: "By all means tell everyone it's minus fifty degrees in the winter and is absolute hell for living."

Two artists, significantly from the northern and southern portions of the region, insist the area's physical makeup has a direct relationship to its art, their art. They are landscape painter Clyde Aspevig of Montana, and wildlife painter-sculptor Veryl Goodnight of Colorado.

"By reason of my choice of subject matter, most of my research travels take me into the Northern Rockies, pre-

70

dominantly Wyoming and Montana," Veryl Goodnight said. "Wildlife art is a field of its own that often overlaps with western art and yet many wildlife artists take off to Africa to find subject material. I've always felt that only by living with the various animals season in and season out could you really become familiar with their ways and attitudes. I try very hard to practice what I preach and spend as much time as possible during every season in the Northern Rockies with the elk, antelope, buffalo, bighorn sheep, raptors and any other animals or birds that happen to come within my reach."

Aspevig is even more detailed and ambitious. He has a plan, a dream, to tell the present part of the region's story.

"I have many plans for future projects," Aspevig said. "To record the vast area of the southeastern Montana landscape before it's ruined by coal development, such as the Tongue River Breaks. I am planning a series on the rivers of Montana, particularly the Yellowstone, as the last of the free-flowing rivers; the Missouri as the last scenic wilderness with its unique breaks; and many of the tributaries, such as the Marias. I will simply roam the state and record everything I can possibly paint in my lifetime, to become known as the 'landscape painter of Montana' and no other place."

Aspevig is twenty-eight years old. He loves painting and attacks his chosen work with feeling; witness this statement

GARY CARTER
*When Starvation
Is A Flinch Away*
Courtesy of the artist

M.L. COLEMAN
Mt. Reynolds – October Snow
Courtesy of the artist

preserve images (often the fleeting moment) for myself and others. Once discovered, the variety and depth of nature are such that all that is required is enjoyment of the range of what is offered."

Coleman is a native of the region, born in 1941 in Livingston, Montana, and raised in Yellowstone National Park where his father was a ranger. Like Tucker Smith, he is a graduate of the University of Wyoming and worked for a time before he felt compelled to commit himself to landscape painting. He served in the military and worked for eight years as a Certified Public Accountant in Denver before moving, in 1973, to Bigfork.

Unlike his colleague, Clyde Aspevig, who specifically intends his subject matter to be the Montana scene, M.L. Coleman plans to paint not only the Rocky Mountain region but whatever or wherever his interests take him. "Although my primary interests (and roots) are in the Northern Rockies and I live and work in this area, I hope that my work and reputation will not be limited to this geographical area," Coleman said. "As a landscape painter primarily concerned with what I call the 'drama of light,' I am interested in many different geographical areas. Regardless of the area, it is my desire to make people aware of and appreciative of the beauty of unspoiled nature."

74

Wildlife sculptor Clark Bronson of Bozeman is another who lives and works in the region but insists he must also have the freedom to work beyond its borders. Most of his bronzes sell outside the region, understandable for an artist whose career has included numerous illustrations for leading wildlife publications, national calendar companies and commissions from large companies. Bronson illustrated three books for Rand McNally and was regularly selling wildlife paintings when he decided to shift to sculpting.

In 1978, he moved from his home near Kamas, Utah, to Bozeman, Montana. He recently explained why. "I have to be outdoors where there's wildlife. I grew up near wildlife in Utah, but the wildlife have disappeared there. Wildlife is plentiful here in the Gallatin Valley. We can drive up the Gallatin Canyon or over to Gardiner (at the edge of Yellowstone Park), or take a canoe along any of the rivers and see wildlife all the time."

Bronson says he has left painting for good. Each year four or five new sculptures come to life in his studio; they are cast at Big Sky Casting Corporation, a foundry he set up at Bozeman, to ensure complete control of the casting process. Unlike many artists, Bronson understands promotion. He issues a regular newsletter from his studio advising clients and potential customers of his work. A recent newsletter, for example, had pictures of him sketching elk, deer and mountain

M. L. Coleman
at his easel.

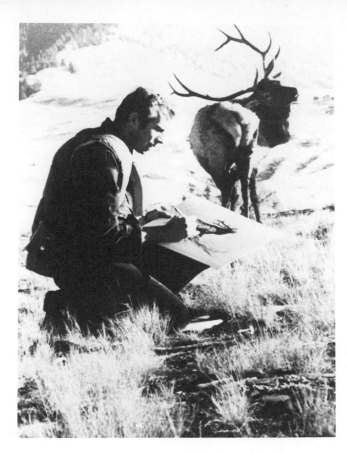

Clark Bronson
Courtesy of the artist

goats in the field. Another photo shows him with a representative of the Hartford Insurance Company, signing a contract for Bronson to create a bronze of their logo, the Hartford Stag. This three-foot bronze is for fifty Hartford offices throughout the United States.

Another meticulously-prepared catalog offers biographical information on Bronson, and includes black and white and color photographs of his bronzes. It also lists his credentials: member of the National Academy of Western Art, National Sculpture Society, Wildlife Artists International, Northwest Rendezvous Group, and Society of Animal Artists.

Bronson advertises, too, through an advertising agency he set up in his own studio. "Clark Bronson Bronzes" ads appear regularly in publications as diverse as *Ducks Unlimited, Montana Magazine, Southwest Art, The Oil and Gas Journal, Audubon, Gray's Sporting Journal, Petersen's Hunting, Portfolio, Sports Afield, Medical Economics, Interior Design, Colorado Dental Journal, Alaska,* and several airline magazines.

Promotional skills are something put to use much more adeptly by the younger artists; they have grown up in the age of television "hype" and understand promotional need and

76

techniques better than their predecessors.

There is also that sense of roots, of belonging to a place and people. Tom Saubert, another of the many young artists working out of Kalispell, emphasized that point. "My artistic stimulation, motivation, and inspiration come from my God and the history, people, and the land that is Montana. It is my home and birthplace...with its timeless expanse and variation."

A graduate of the Cleveland Institute of Art, Saubert's work — both painting and sculpture — has won awards in competitive shows in Montana, Washington, Wyoming, and Ohio. One drawing was accepted into the National Drawing Show at Rutgers University in 1978.

Most of Saubert's drawings depict scenes familiar to the way of life in the area he calls home; views of people intent on being who and what they are. Faces, worn and weathered and very real, at the livestock auction, a coffee shop, or bar, wherever they gather. "Each person possesses a special spirit with various ranges of moods, emotions, temperaments and mannerisms," Saubert said. "These are the qualities that I look for and strive to embody a piece with, that it might go beyond mere likeness or decoration, being able to stand by itself, possessing a character of its own."

We have, then, a wide range of subjects and themes: history, landscape, wildlife, ranch life, outfitting, people, moods of

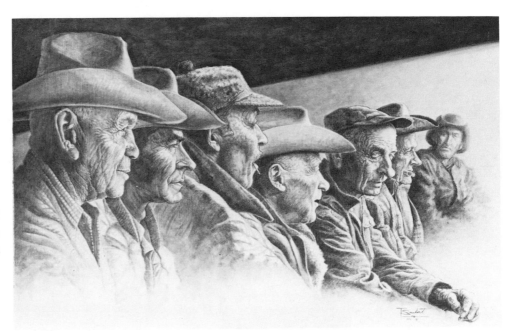

TOM SAUBERT
Two-bit Steers
Courtesy of the artist

MARV ENES
Dreams and Determination
Courtesy of the artist

nature; the awareness of a region and its uniqueness.

Elmer Sprunger said it this way: "The people painting today's thing are landscapers, wildlifers, and western-today cowboy artists, and modern-day Indian painters. History has already been made. We have to make some more. I believe the quality of our art is getting better and can stand up to art anywhere."

Another who is convinced of the improving quality of western art is Bob Morgan of Helena, now a widely-recognized artist in his own right, but for twenty years curator of the Montana Historical Society Museum in Helena and a recognized authority on the works of Charles M. Russell.

"One of the reasons is the intimate relationship both artist and viewer have with the subject matter," Morgan said. "We're not so sophisticated out here that a client is just a client. Often he or she becomes a friend. We're still 'west' enough that we want to like people and people come here and fall in love with the mountains, see a painting that captures the essence of their experience here."

chapter eight
The People Buy In

*N*EWSWEEK MAGAZINE, in its September 10, 1979, issue,
devoted two full pages, including a photograph of the 1979
"Quick Draw" contest at the Northwest Rendezvous of Art
held in Helena, Montana, and reproductions in full color of
three western paintings. But its text was burdened with the
longstanding, condescending attitude westerners have come
to expect in the eastern press. Remington and Russell, for
example, were referred to as the "granddaddies of the tradi-
tion" and the story ended with an insulting tone: "Stories of
speculation and rapid resales are as rife among dealers as tall
tales around the campfire. These days, if a cowboy mentions
Old Paint, he's probably not talking about his horse."

Even *Newsweek,* however, acknowledged the high stakes
that have become commonplace in art of the American West.
Money talks, and when it does people everywhere, even in the
East, listen, however grudgingly. *Newsweek* continues: "Last
spring, a scene of buffalo hunters by Wyoming artist John
Clymer brought an astounding $72,000 at a Houston auction.
The National Cowboy Hall of Fame has grossed more than

79

$500,000 so far this summer on the 82 works in its annual exhibition and sale, and a group called the Cowboy Artists of America, which sold $250,000 worth of art in a single evening last fall, expects an even bigger stampede at its auction this October in Phoenix. Dealers say that the value of works by prominent Western artists has doubled in the past five years and is rising now by at least 20 percent a year."

Dick Ettinger, owner of the Flathead Lake Galleries at Bigfork, suggested that much of the sentiment coming out of eastern art critics and dealers is sour grapes. "Every time a western art show is held, it's setting new sales records," Ettinger said, "and we're repeatedly seeing more than $100,000 being paid for a western art painting. Why, three paintings went for more than that at the last Houston show, where there's a lot of oil money getting invested in art of the West."

Consider the one million dollars that Dr. McCracken reported was paid for the Frederic Remington masterpiece, *Downing the Nigh Leader*. Artist Bob Morgan, a founder of the Northwest Rendezvous Group, believes part of the contention is that artists in this region don't need acceptance in eastern circles to be successful.

"Years ago, to achieve distinction as an artist, it was nearly mandatory that you be shown or exhibited in New York, not on the East Coast, but *New York*. But now there are annual

JOHN CLYMER
Gold Train
Courtesy:
Buffalo Bill Historical Center
Cody, Wyoming

80

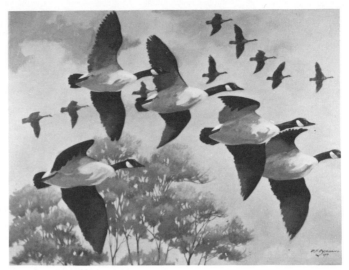

BOB MORGAN
Canadian Geese
Courtesy of the artist

shows, galas, etc., here in the West and Southwest and Northwest that have supplanted the New York Syndrome," Morgan said. "Artists today really don't care about the acceptance of the eastern art establishment, because they can make a better living in their own region, free of the gallery rip-off of the East and the notoriety that will get you a cup of coffee if you have the money to pay for it."

Morgan said that formation of artist groups such as the Northwest Rendezvous Group, the Cowboy Artists of America, and the National Academy of Western Art all testify to the earnest desire of the West to supplant what has heretofore been a close circle of "in" people in the East.

Morgan suggested that the Southwest long ago supplanted New York in terms of prominence of truly American art and now there are movements afoot to supplant the Southwest.

"Money is the key. The Cowboy Artists show in Phoenix, the Houston show and the National Academy of Western Art show bring in money, with a capital M," Morgan said. "A half a million is not unusual and is expected. This is what creates the 'hype' needed to publicize the show and the region. If this type of show were held in New York, there would be more ballyhoo than you could shake a stick at, but they get little or no attention in the national media. Let Parke-Bernet sell a Russell of note for $152,000 and it makes the news services, but let a contemporary artist sell a painting for $225,000 and it doesn't get a line. Strange, isn't it?"

Whatever it is, people aren't misdirected by such attitudes from outside the region. Professional collectors, dealers, galleries, individuals by the thousands are buying the western

Northwest Rendezvous Show,
Helena, Montana, 1980.

art phenomenon regardless of what New York, the eastern art establishment, or *Newsweek* reporters might think. The best way to treat such attitudes, it seems, is to pay them no heed.

"Western art has always had a negative attitude in the East, but the interest has shifted now," Dr. McCracken said, "There are more collectors and artists in the West today than any other school of art in the country."

A fundamental distinction must be understood at this point: between those artists who insist their subjects be "western," and those who simply use western subjects and themes as the basis of their art. The line between them is fuzzy, perhaps defying delineation. But it does exist in the mind of the artist if nowhere else. That is why some artists painting the West don't want to be known as "western" artists. They want their work to stand on its merits, whatever the subject matter.

Bob Clark, librarian at the Montana Historical Society posed an interesting question in this regard, noting that a comparison can be made between regional attitudes vis-à-vis almost all art forms.

"I've often wondered if they have questions like 'Is what I'm doing art? And do they compare their work with what has gone on in Europe? Sometimes I wonder if western art isn't still a colonial defensive posture. In both literature and art, there seems to be a need to justify, defend and compare themselves with other historic eras," Clark said.

Among those who do think and talk about such things are

James Bama of Wyoming, and Frank Hagel of Montana.

"To me, the west is merely a vehicle to say what I want about life, about old people and dignity, and hard work, which I happen to believe in (I was brought up that way)," Bama said in an interview published in *Wyoming News*. "But I don't ever want to think my subject matter is what will make me a good or bad artist. That's the danger of what we call western art. I never came out here to be a western artist, I just came out here to paint. It was arbitrary that I moved out west. My original thought was to move to New England. Then I would have been painting fishermen and hopefully would be making the same statement about life there that I am here. By sheer coincidence, again, western art really took off just when I moved out here, and people will associate me with western art, which I think is devoid of a lot of content. Subject matter is what sells a lot of paintings, and I know it sells a lot of mine."

Unlike Bama, Hagel is native to the region, establishing himself first as a commercial artist before returning to the

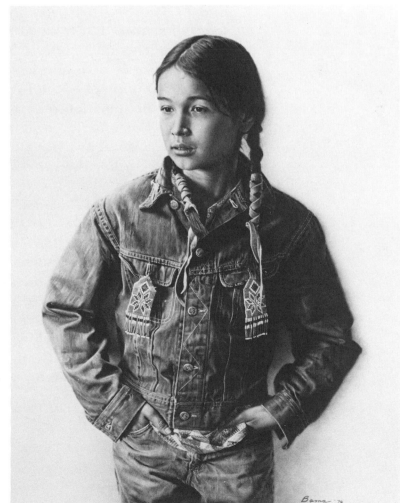

JIM BAMA
Twelve-year-old Sioux Indian
Courtesy of the artist

FRANK HAGEL
Untitled sketch
Courtesy of the artist

Northern Rockies. He dismisses disparaging remarks that much of western art is mere illustration. "Ace Powell was disparaged, as Charlie Russell was, for being an 'illustrator,' as if that was a bad word and made him less an artist," Hagel said. "Of course, the people who make those remarks can't seem to realize that most of the great paintings of the past, Michelangeo's illustrations of passages from the Bible, for instance, are illustrations of some kind or other, and I'm sure the great paintings of the future will be, too."

Part of the question rests on one's understanding of what constitutes art and, more significantly, who is to decide what is and what is not art. Obviously, the mood is not in vogue to let anything other than the work of the artists of the region speak for itself.

Ginger Renner of Paradise Valley, Arizona, who served as mistress of ceremonies for the 1980 Rendezvous of Western Art in Helena, put it well in one of her talks at the Rendezvous: "Most of them [western artists] paint out of a heritage they long to preserve. It is not an anachronism to paint a time and place one admires."

Mrs. Renner's perspective is particularly meaningful. For nine years she was director/owner of Desert Southwest Art Gallery at Palm Desert, California, and Trailside Galleries in Jackson, Wyoming. She has written extensively on western

84

Gary Schildt
painting Ginger Renner's
portrait.

art, participated in seminars as widespread as the National
Cowboy Hall of Fame to the Spokane Art Museum, the Montana Historical Society, and the Los Angeles County Art
Museum. She presently is chairman of the Western Art Associates of the Phoenix Art Museum and also functions as
Touring Docent of that institution.

She had this to say about contemporary art in the 1980
Rendezvous of Western Art catalog: "Today, no person, anywhere, looks down on Western Art. They simply cannot afford to. We have, in short, arrived. And that is because, fortunately for us, these giants (Bodmer, Catlin, Russell, et al) have
been followed by a new group of younger artists, most of them
contemporary, who are well grounded artistically as well as
historically, in the spirit of the American West. They may
draw their inspiration from the giants of the past, but they are
dedicated to bringing to this great tradition their own individual styles and talents, their feelings, their personal experiences, their unique gifts of expression."

The process of defining the region's art has been taking
place and, since it is dynamic, will continue so long as life
itself exists. Some of the work will achieve recognition and
lasting value. Much of it will not, just as with any school of art
in any era. In the meantime, the process will have to simply
work itself out with all the vagaries of place, time and circumstance — and the understanding that there may not be any
ultimate answers. The acceptance of artistic work is akin to
its creation; it begins as an individual, subjective force and
gains momentum and recognition as its individual acceptance and approval become a common unity.

chapter nine

A Notion of Authenticity

THERE IS a fundamental aspect to art of the West that beginning artists and collectors alike must consider. It is called authenticity.

The term itself is nebulous, but its practitioners know what they mean when they use it: a truthful representation of what they're painting. Accuracy is important, not just including every minute detail, but in the broader components that make up the subject matter and the theme of the painting. Details of significance are what count, not merely details.

Authenticity is a key word in western art. It is the only criterion for some. Others consider it a bane to artistic expression, but whatever the opinion, the notion of authenticity underlines both the way art of the region is done and how it is viewed.

It has always been that way. Artists of no less stature than Frederic Remington and Charles Schreyvogel carried on a celebrated and, ultimately, debilitating feud around the theme of authenticity. Remington, who staked his reputation on the detailed accuracy of his work, took exception to some

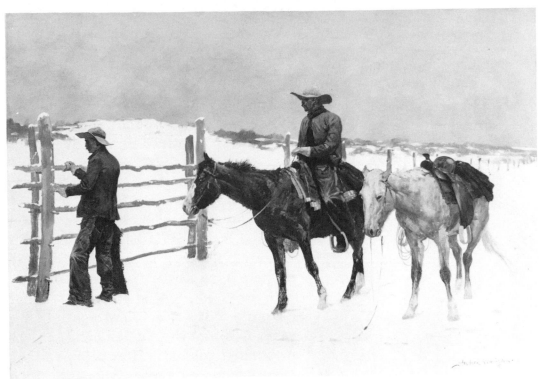

FREDERIC REMINGTON
The Fall of the Cowboy
Courtesy:
Amon Carter Museum
Fort Worth, Texas

of Schreyvogel's work because he felt it wasn't accurate. Equipment and uniforms were shown in historic scenes years before they existed.

In more recent times, a whole spate of paintings surrounding the Custer battle on the Little Big Horn have given rise to vociferous public debate about their authenticity, their approximation of the scene as it really might have been. Interestingly, it is two of the most carefully researched and executed paintings of that event, one by a man living at the time of the battle and the other born years afterwards, that have enjoyed the most public and critical acceptance — precisely because they are considered authentic. They are *Custer's Last Stand* (1899) by Edgar S. Paxson and *After the Battle* (1955) by Billings artist J.K. "Ken" Ralston.

In Paxson's case, more than twenty years of painstaking research and sketching were part of the development of his most famous painting, which today hangs in the Whitney Gallery of Western Art at Cody, Wyoming.

A year after the battle, Paxson was at the site on the Little Big Horn. He went over the ground with Major Marcus Reno, who had participated in the battle and helped bury the dead. Subsequent visits were made to the site with Curley, who had been Custer's scout, the Sioux chiefs Gall and Rain-in-the-Face, and the Cheyenne Two Moons. Ultimately, Paxson fill-

ed a notebook with his observations and questions. Pictures of some of the major participants were obtained so their likenesses would be authentic.

Over two hundred figures are included on the six by nine foot canvas, Paxson's masterpiece in his day and now considered an authentic rendering of the battle. "It is my conclusive opinion that the Edgar S. Paxson painting, *Custer's Last Stand,* must be accepted as the most accurate portrayal of the historic Battle of the Little Big Horn," Dr. Harold McCracken said in 1963 when it was announced that the painting would be displayed at the Whitney Gallery.

Before making that statement, McCracken said he made a careful study of the painting and checked its historical representation of the Custer incident against official and other published records. He checked the artist's notes, and excerpts from his diaries regarding Paxson's sources of information.

"Through fourteen years he [Paxson] pursued a determined research of the Custer battle, seeking out every possible source of information, making notes and sketches. Then he spent an additional eight years in the actual painting of the big canvas, which was completed in 1899," McCracken said.

In the case of Ralston's painting, a careful re-creation of the aftermath of the battle, the artist also put in years of research and observation at the site of the battle. His grand, eighteen-foot-wide canvas portrays thirty-nine different incidents that occurred immediately after the battle. In each case, the accuracy of these incidents is supported by a vast amount of historical research dealing chiefly with Indian accounts. The distinguished Montana historian, K. Ross Toole, termed Ralston's painting "The most authentic portrayal of the battle yet painted."

I talked with Ken Ralston in his Billings studio and the question of authenticity came up during our interview. He insisted that everyone who paints the Northern Rockies region should first sit down and read the Lewis and Clark journals. They are the basis for understanding the history of the area, he said.

Ralston also talked at length about a sure giveaway in the works of some artists: straight roads or wagon tracks in ter-

J.K. RALSTON
Buffalo

rain where horses or oxen couldn't possibly have pulled such loads. The roads and trails used to go with the lay of the land; they contoured with it, on it. Most often travelers took the easiest way, even if it was more roundabout.

The late Irvin "Shorty" Shope of Helena was another stickler for authenticity. Like Ralston, Shope had worked as a cowboy and horse wrangler. He also spent hours in library and field research. "I'm strong for historical accuracy, which might account for the fact that I earned almost as many history credits as art credits while at the university," Shope told me.

For many artists, like Montana's widely-acclaimed Fred Fellows of Bigfork, commitment to authenticity in portraying the West manifests itself in a collection of Indian and western artifacts, that he says not only help achieve technical accuracy in his paintings but also serve as a source of inspiration. Fellows, a past president of the Cowboy Artists of America, insists that "paintings must be factually true to the period of history and people portrayed, as well as being creatively pleasing. I feel it necessary to know a subject thoroughly before making a statement about it."

Fellows made another statement about authenticity early in his career that is worth repeating: "I've been a working cowboy and rodeo hand (he's a champion roper) and from

Fred Fellows
in his studio.

Courtesy:
Ruth Steel
Bigfork, Montana

this experience know firsthand much of what I portray on my canvases. However, I also believe that research is vital to establish historical accuracy and authenticity. Painters today have an advantage over many of our earlier counterparts. We have added insight, through study and research, into the history of the Old West and I feel we're able to draw more meaning and perspective into our interpretations of it."

That works for some, like Fellows, who are both thorough and committed to the notion of authenticity in their work. But critics of western art are quick to point out that everyone isn't that careful, or committed. They note that while the integrity of a piece of work is dependent solely on its creator, the reputation of western art as a whole is threatened by those who treat details in their work lightly or inaccurately.

"I still see a preoccupation with historic art by artists who are not historians, painting the Old West that never was," Tucker Smith said. "There are too many artists who don't take their art seriously enough."

Bud Helbig of Kalispell, a member of the Cowboy Artists of America, said much the same thing during a recent conversation at an art show in his hometown. We were discussing a painting that obviously had authenticity problems and he kept shaking his head from side to side. "He's got to make his work more authentic. It just won't stand," Helbig said. To him, authenticity is an absolute.

90

Gerald Peters, in his excellent publication *Classic American Painters* made a specific reference to the power of authenticity in the works of Charles Russell and Frederic Remington. His is an astute observation: "The genius of these two artists was founded on a larger talent for authenticity, one that was inseparable from their relationships to a Western way of life. Each in his own way was able to choose, without evaluating, the facts of a situation or scene, then combine and render them in a way that intensified their significance."

Authenticity, then, is not seen as the minute recording of every detail of a scene. Rather, it is the accurate presentation of those details that combine significantly to give a scene meaning, purpose, and vitality. From the authenticity of that presentation comes the viewer's understanding of the particular subject involved.

Yet some people don't care about such things; their only interest is the artistic dimension. Is it a good painting or not? Does the sculpture work? They look only at the aesthetic elements. Most of the artists insist, however, that they try to get both artistic dimension and authenticity; one in fact, enhances and supports the other.

Verne Tossey of Portland, Oregon, whose work includes many scenes of the Northern Rockies region, exemplifies those committed to the notion of authenticity and the formal elements of art. He sent this description of his approach to his work: "He [meaning Tossey] will work only from original

TUCKER SMITH
A Break
Courtesy of the artist

Verne Tossey

sources, never from someone else's photos or other types of reference material. Every bit of landscape and subject matter, animate or inanimate, he has visited in person and either sketched or photographed. It is this meticulous attention to authenticity that helps make his paintings a sincerely beautiful portrayal of our western heritage."

Tossey worked many years in New York as a commercial illustrator; in 1972 he moved West and chose to work in fine arts. He is outspoken about some of what he sees in the field. "The shopping malls and motels are filled with the shoddy work of too many ill-trained 'western artists.' This, plus the many artists painting only 'for the buck,' cheapens not only western art but all art."

Wildlife artist Ron Jenkins listed as a "pet peeve" the lack of integrity in some work he sees. Marv Enes suggested that artists today should see their role much the same as their predecessors, to record and interpret what's going on around them. "We're making a record."

John Brice believes that the two schools of thought are in constant tension. "People talk about it a lot. A lot of people inspect a piece and then ask if it is historically correct. Many times it is only when this criterion is met that they're able to approach the work as art, and I think that really gets in the way of art for art's sake."

Sculptor-woodcarver Bill Ohrmann of Drummond, whose own wildlife sculptures are highly praised for their anatomical authenticity, said he "wasn't sure that an artist should sell his soul just to have everything authentic. I'm thinking of those who can splash color on a canvas and make a real pleasing picture. Those who have to have everything down to the finest, authentic detail can get it with a camera, but an artist should try to reach for something deeper. Like Picasso with his faces with eyes all screwed up and out of place — well, maybe he tried reaching too deep."

Brice suggested there are times when an artist has to be totally authentic or his work loses credibility, but there might be times when minutely detailed accuracy isn't important. He used an example of a wildlife artist painting a moose. "If a moose is shown in a spring setting with a fall coat, you obviously react to that, though some people might be willing to look past that discrepancy to capture the meaning or notion of what the artist was trying to do in the painting."

Most artists acknowledge a commitment to the notion of authenticity. M.C. "Mike" Poulsen explained why. "Most of the general public won't notice if a painting is a fake, but an historian, or a technical painter like Bama will pick you apart. They're going to find it. As far as a career as a fine artist, I feel I have to be technically correct so I can't be

Ron Jenkins
Artist working
in his studio

Clark Bronson
Veryl Goodnight

disputed." Since his speciality is painting outfitters at work in the high Wyoming mountains, he feels details are essential. "In the outfitter trade, you have to know the proper way to tie a diamond hitch on a pack horse."

Wildlife sculptor-painter Veryl Goodnight of Colorado keeps a "cadaver freezer" of dead animals and birds — road kills or animals that have died of natural causes — to aid in anatomical accuracy. An *Art West* magazine article about her by Helori M. Graff gave insight to the effort an artist will go to in achieving authenticity: "When she was working on *Elk Mountain Burn,* which subsequently won the 1978 Gold Medal in sculpture in the Wildlife Artist International Competition, her total commitment to authenticity led her to call a local taxidermist to request the head of a bull elk. She needed the jaw and tongue to accurately sculpt the anatomy of the mouth of a bugling elk. Fortunately, the taxidermist was able to fill her request and Veryl toted the head of the elk up to her studio to study the exact detail she needed."

Many artists whose work demands authenticity, like Goodnight and sculptor Clark Bronson or wildlife painter Elmer Sprunger, spend hours in the field observing the animals that later turn up on canvas or in bronze. And they sketch and photograph for future references.

"I don't see how you can do something if you can't draw — how you can do something with good balance, design, composition," Bronson offered.

An article about Sprunger's work in the *Flathead Valley*

94

Outdoor Journal in 1979 by Ruth Steel contained insights into his work that revealed how at least one artist handles authenticity: "The artist has his secret places that he visits when he needs to observe a particular species — a bear, a cougar; deer or elk, or perhaps, chipmunks and squirrels. He knows the country, the habitats, the time and season to observe them — and he knows the wildlife. That's why his paintings come alive on the canvas. His subjects are in a natural setting, going through their normal business of the day or hour — feeding, resting or playing. His lifelong familiarity with each detail results in a flawless reproduction."

Familiarity is the key. Whether through field trips to a given area like the site of the Custer battle on the Little Big Horn, or meticulous library research — authenticity comes from the artist being familiar with his or her subject, ultimately becoming something of an authority on it. That's why authenticity is a requisite for art in the West, in the Northern Rockies. It gives one's work the power of historical accuracy enhanced by subjective interpretation and artistic expression.

Wyoming artist Nick Eggenhofer probably said it best, commenting in the book *Eggenhofer; The Pulp Years* by John M. Carrol, on things a western artist should be able to do: "In doing artwork pertaining to the western scene there are a few important things to remember. Since the horse was of such

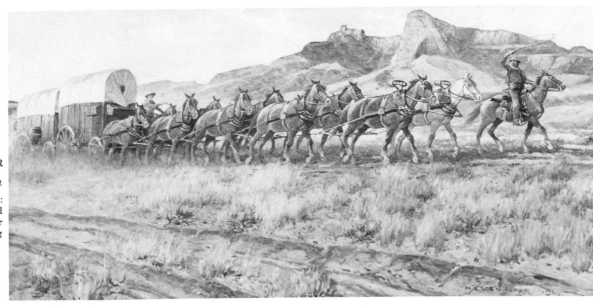

NICK EGGENHOFFER

Wyoming String Team

Courtesy:
Buffalo Bill
Historical Center
Cody, Wyoming

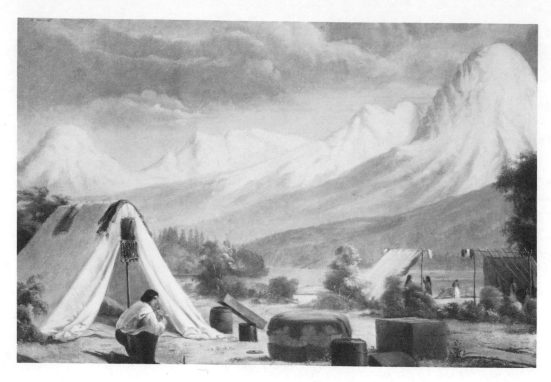

PAUL KANE

*The Encampment –
Rocky Mountains*

Courtesy:
Glenbow Museum
Calgary, Alberta

tremendous importance in the development of the West, the young artist should at least get on a horse and ride once in a while. This does not mean he has to become a champion rider or expert roper, but it is vitally important to know what it feels like to sit a horse. If not, it will show up in your art very quickly."

Indeed it does. That's what authenticity is all about.

chapter ten

A New Outlook

DR. HAROLD McCRACKEN leaned back in the chair in
his cavernous office and asked if I had time to hear a story. Of
course I did. I had driven to Cody to visit with McCracken and
interview him. Time was something I had more of than he did.

"I want to tell you about the grizzly bear that was hiding in a
log. It involves one of your Montana people," McCracken
said. I detected an impish grin on the face of this dignified
man whose books on George Catlin, Frederic Remington and
Charles Russell had made him famous.

"Bill Ohrmann was down here for a show, about 1971 or
1972, and he knew, as most everybody does, that the grizzly
bear is my pet interest among wildlife. Bill gave me a carving
of a grizzly with a fish in its mouth and I've never forgotten
what he said about it. He's a modest man, you know, and he
told me 'I found this inside a log and decided you should have
it.' That particular Ohrmann wood carving is in my home."

So Bill Ohrmann found a grizzly bear hiding inside a cot-
tonwood log and opened up new horizons by releasing it. He

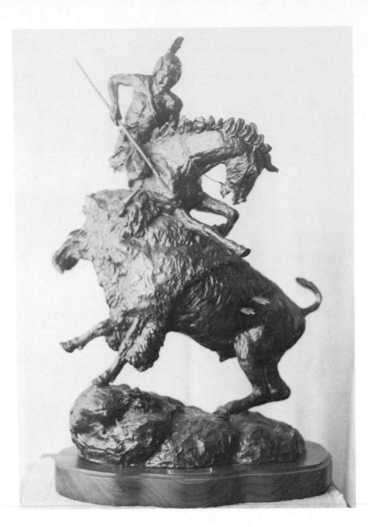

BILL OHRMANN
The Buffalo Hunter
Courtesy of the artist

demonstrated that new ways of looking at things can change perspectives, outlook, and potential. The same thing has happened in the world of art around him. For Ohrmann, it was release of a powerful talent, but the joy and release of talent cuts two ways. Consider, for example, this comment made by McCracken some years ago: "The first time I met Bill Ohrmann was when he visited my office in the Whitney Gallery of Western Art and asked if he could show me some wood carvings he had made. Although his name was new to me, of course I would look at his work, as I am always willing to do. He went out to his auto in the parking lot and returned with his wife, both carrying two or more sizeable carvings. Before the first one was set on a table, my interest was excited and in less time than it had taken to carry them up to my office, I had decided to exhibit some of this man's work. It was I who asked for that privilege and not the sculptor."

98

McCracken is blunt in calling Ohrmann one of the finest contemporary wood carvers in the western field. "The first exhibit of Bill Ohrmann's wood carvings in the Whitney Gallery was throughout the 1971 season. The group of eight carvings was shown alongside a larger display of bronze and hydrocal castings of the work of another Montana sculptor, Bob Scriver, who is among the finest of our contemporary sculptors. There were also some art bronzes by Frederic Remington and James Earle Fraser. To show Bill Ohrmann's wood carvings in such company was really putting his work to the most critical test possible. However, the reaction from the more than 200,000 visitors to our museum during the 1971 season was so favorable to Ohrmann's work that another group was requested for our 1972 season celebrating the 100th anniversary of Yellowstone National Park."

There was new enthusiasm and support for the entire American art scene about that time. Art of the American West and the Northern Rockies had shared in that "boom" as *U.S. News and World Report* called it in 1967. The phenomenon they devoted four pages to did not include the tongue-in-cheek denigration *Newsweek* (see Chapter Eight) gave the subject in its 1979 article. The outlook, as *U.S. News and World Report* indicated, was bright everywhere in America. "One business that is booming as never before in this country is the buying and selling of American art. The idea of investing in a paint-

Bill Ohrmann

BILL OHRMANN

Trailing the Hunting Horse

Courtesy:
Marie's ART-eries

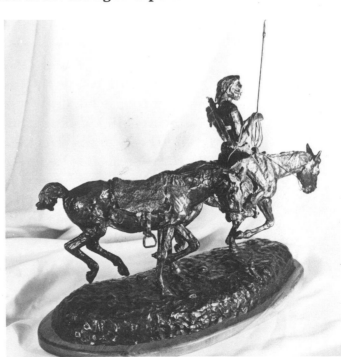

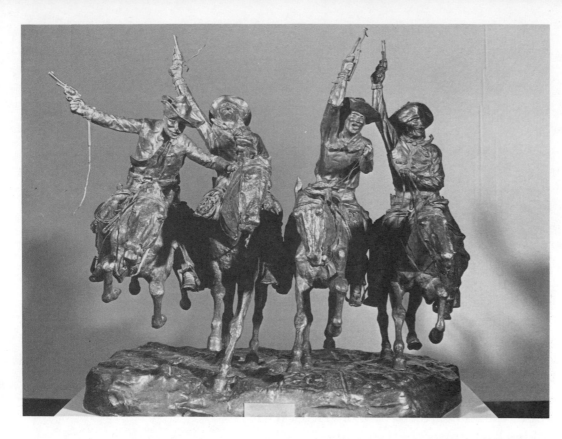

FREDERIC REMINGTON
Coming Thru the Rye
Courtesy:
Buffalo Bill Historical Center
Cody, Wyoming

ing as a hedge against the future is found to be catching on in a big way. And buyers are turning increasingly to American Artists who have long been overlooked in favor of the Old European masters."

Fully five of the nine photographs illustrating the *U.S. News and World Report* article were western art, including a view of Frederic Remington's sculpture *Coming Through the Rye* and Charles M. Russell's painting *Red Man's Wireless*. In addition, extensive mention was made of Frederic G. Renner of Washington, D.C., one of Montana's most admired native sons and a connoisseur of Russell art.

Renner, who grew up in Great Falls, is considered the foremost living expert on Charles M. Russell. He has played a major role in shaping the direction of the explosion in western art. Not only has he put together an admired and representative collection of Russell paintings, drawings and sculpture, but he has written extensively about Russell. Renner also has played a major role in the astounding success of what many consider the single most important promotional art event of the region over the past few decades — the annual C.M. Russell Auction of Original Western Art in Great Falls.

100

The annual auction began inauspiciously, if with considerable ballyhoo, in 1969. Sponsored by the Advertising Club of Great Falls, it was called "The Biggest Wing-ding in Ad Club History." It is doubtful if anyone realized at that time the significance this event would come to have.

Fred Renner was honorary chairman of that first auction and he made a statement that seems now, with benefit of hindsight, to have been prophetic in its understatement. "Such an event as the western art auction contemplated by the advertising club cannot only aid the cause of modern western artists, but will help the [C.M. Russell] gallery as well."

Four hundred people from seven states and twenty-one Montana towns had attended the auction, held during a bitterly-cold March snowstorm. And more than $20,000 had been raised. The amount achieved above expenses was to benefit the new and expanded C.M. Russell Museum in Great Falls.

Imagine, then, the excitement that reigned after the 1980 auction. More than nine hundred people attended. One hundred artists and dealers displayed work. The receipts were almost $300,000 *more* than what was realized in that initial auction in 1969 — $319,230.

Sculptor Joe Halko of Great Falls credits the auction with

Fred Renner.

Left to right:
Norma Ashby, Fred Renner,
and Sam Gilluly at first
C.M. Russell Auction, 1969.

being the greatest single factor causing increased awareness
of art of the region. So does M.C. "Mike" Poulsen, who sug-
gested it has become one of the finest shows in the U.S. and
that it was a privilege for an artist to be in the show. Land-
scape painter M.L. "Mike" Coleman of Bigfork credited the
show with two significant effects — one within the region and
the other outside it.

So widespread is its influence that in 1979 the C.M. Russell
Auction received the Old West Trail Foundation's Trailblazer
Award as the most outstanding community event in the na-
tion. Fittingly, television personality Norma Ashby of Great
Falls was in Omaha to accept that award on behalf of the
auction's sponsor, the Great Falls Advertising Federation.
Her enthusiasm and promotional efforts were significant to
the early success of the auction.

"It [the auction] was an idea whose time had come," she
said. "The first year it was held the Russell Museum wasn't
even open. It was closed for remodeling, but we were so sure
the idea was right we were determined to hold it anyway. We
Ad Clubbers had never produced an auction in our lives, but
we knew auctions could be fun and profitable and that an
auction of western art would be unique to our area. Using a
name no other community could claim, C.M. Russell, we were
on our way."

The auction has netted, above expenses, more than $300,000
for the museum. But Museum Director Ray Steele noted that

102

the auction has served other purposes, too. It has unified the community behind development of the Russell Museum and it has given the auction national exposure.

Most significantly, the auction has lent credence to the regional art movement. "Through the Russell Auction and its related activities like the dealer rooms, chuckwagon brunch, seminars, receptions and quick draws, thousands of people have been exposed to the world of western art and have become avid collectors themselves," Mrs. Ashby said. "They have discovered you don't have to be rich to own an original piece of western art. The majority of works sold at the Russell Auction go for under $1,000."

The auction's influence underscores the fundamental rule Dr. McCracken noted: exposure is crucial.

The Russell Auction is one of many now held throughout the region, though it is the most significant and prestigious. Another show highly regarded by artists is the annual art show and auction in Spokane — the Museum of Native American Culture (MONAC). In spite of problems of crowding, parking and chaotic scheduling, the 1980 MONAC show and sale grossed almost a quarter of a million dollars, most of it on the sale of some 250 works of art.

Another event that has achieved immediate popularity and success is the Sun Valley (Idaho) Art Show and Sale. The third such show was held July 3-6, 1980, at Elkhorn Village in Sun Valley. The show-auction grossed over a half million dollars in 1979, only its second year.

It is significant that a number of shows and new galleries have opened up throughout the region in the last twenty

Left to right:
Tom Sander, Steve Rose, and
Dr. Tom Rulon jurying the
1980 C.M. Russell Auction.

years. Annual shows held at Kalispell and at Ellensburg and Yakima in Washington, among others, not only have assisted in the exposure and promotion of art of the region, but have added to its lustre.

There also have been significant new and expanded museum facilities. Examples are the C.M. Russell Museum in Great Falls; the Museum of Native American Culture in Spokane; the Whitney Gallery of Western Art and its companion, the Buffalo Bill Historical Center in Cody; the Bradford Brinton Memorial Ranch in the Big Horn Mountains of Wyoming; the Glenbow-Alberta Centre in Calgary; the Montana Historical Society Museum and Russell Art Gallery in Helena; and many others.

John R. Brice put these interrelated phenomena into perspective: "Yes, money does talk, and it will affect everything from the individual artist to the number of galleries and the caliber of our museums, as well as the public perception of our art inside and outside the region."

Galleries, shows and auctions have been good for the artists involved — but there is still considerable sentiment and a variety of opinion about them among artists. Those sentiments vary from enthusiastic support to downright suspicion and dislike.

Wildlife painter Ron Jenkins and sculptor Clark Bronson expressed reservations about shows and galleries. Their feelings were echoed by many other artists.

"I don't have any misgivings about what is occurring except the overselling of art. Too many galleries have sprung up which aren't equipped to handle art in a nice way," Jenkins said. "A lot of customers have become soft because of this and are just now beginning to sort it out. I find myself at times apologizing for gallery-owner friends who have offended clients or simply made a sloppy showing from time to time."

Bronson said he wasn't sure if he wanted to participate in most shows. "A lot of them are like big television game shows, the way they auction some things off. Some really ruin it, always getting the same people and auctioning too much work off too cheap, or championing some artists to the exclusion of others. It hurts the rest of the art, and a lot of times the judging at such things is political."

104

Will Rogers and C.M. Russell
Courtesy:
C.M. Russell Museum
Great Falls, Montana

Painter Clyde Aspevig pointed to the dilemma most artists are in. "I feel that galleries, shows, and auctions have added much to the excitement in buying art, but as an artist who has sold from my studio and had my own shows, I have had the experience that my work sells better when I sell it myself. The main problem is exposure and what kind of reputation an artist is looking for. Several local Billings artists have remained strictly on a local level (LeRoy Green and Hall Diteman for example) and made good livings at it. However, the value of their work seems to suffer when it is offered for sale elsewhere, simply because no one has ever heard of them."

Wildlife artist Robert Bateman of Milton, Ontario, whose work brings him often to the Northern Rockies, suggested a distinction must be made when considering the subject of auctions, shows and artists. "Marketing, auctions, P.R., etc., are all games that have nothing to do with art. They are necessary if one is to eat, but should not be taken seriously and never allowed to affect one's work."

Necessary to eat. Indeed! The practical side of being an artist, the fueling of the life process, always rears its head. Perhaps it is good to come down to earth once in a while, to realize that even in the pursuit of such a noble goal as artistic expression, there is the realistic side of things. John Brice put

Bob Morgan at work

it well: money talks. Or does it really dictate the direction and the pace of things in the art world?

Brice suggests direction and pace are both at work. "You can ask some artists why they don't do certain things and the answer you get is 'they don't sell,' so some artists fall into formulas that work for them financially. There are some artists who have the wherewithal and magnitude of individuality to paint what they want rather than let a potential buyer's taste determine their work, subject matter, and style; but not a lot of them."

Elmer Sprunger thinks there is an ever-constant tension involved. "We all swing from artistic ideals to the basic need to put beans on the table. I don't know where it goes from need to greed, but I think if artists around here would become more tied to their paintings and less tied to the dollar, the economics would take care of itself."

Bob Morgan, who assisted the Great Falls group in getting the first C.M. Russell auction going in 1969, has both praise and words of caution for the influence of auctions. "I think that auctions have been good overall for the art community, but more and more I find that they tend to be manipulated by the dealers involved. Most established artists will not participate in this type sale because of the various manipulative procedures involved."

106

What procedures? Morgan outlined a few:

• To insure quick sales, minimum sales or reserves are discouraged, and, at times, bargain basement prices for the artwork are the result. From this, the artist can have his reputation and financial situation badly hurt.

• An auction often takes on a carnival atmosphere; most lack the dignity of a straight sale.

• Dealers have a tendency to use auctions as a launching-pad for artists within their own stable, and will manipulate bidding to get high prices for works, later reflected in the pricing structure of that artist for several years.

"As an example, in one Montana show several years ago, an artist's works were exhibited in several dealer rooms at six to eight hundred dollars each," Morgan said. "The artist had a painting in the auction which, when brought up for sale, suddenly spurted beyond the normal price range to what was then an exorbitant price. This created quite a stir among collectors, until it was found out that two of the dealers had conspired to raise the price. It was evident when the dealers' rooms reflected the price increase the next morning."

Morgan, like the others, suggested that perspective must be kept in the forefront. Overall, auctions, shows and galleries combine to help not only art, but individual artists, because it gives them exposure and new markets.

So do professional and individual collectors, the people enamored with either the West, the Northern Rockies, or a specific artist. Sometimes, too, the individual collector be-

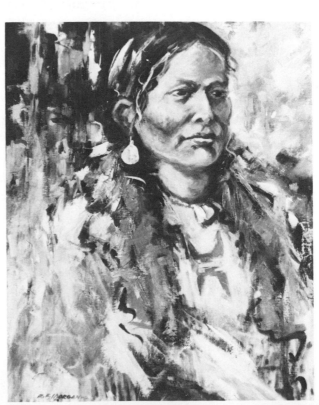

BOB MORGAN
Blackfoot Girl
Ah' Tose
Courtesy of the artist

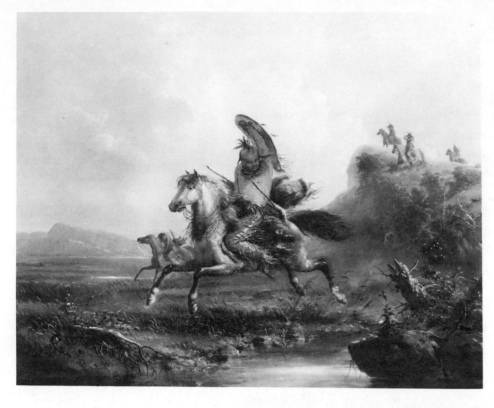

ALFRED J. MILLER
Beating A Retreat
Courtesy:
Museum of Fine Arts
Boston, Massachusetts

comes the professional and highly-sought-after authority in a given field. Frederic Renner, who amassed the bulk of his formidable collection of Russell's works during his forty-year career in the U.S. Department of Agriculture, is an example. So is Kalispell gynecologist Dr. Van Kirke Nelson, who has put together a sizeable personal collection of past and contemporary western art works while maintaining a busy medical practice.

Renner and the personable Van Kirke Nelson typify the serious private collector. Their initial interest is followed by the pursuit of knowledge about the subject; in time they become recognized not only for their collections but for that knowledge. Authority-status is given them and they, in turn, gain both prestige and influence in the field by what they say and whose works they collect or promote. They also, as did collector Dick Flood of Trailside Gallery fame in Jackson Hole, get in on the ground floor and amass the works of many artists just before the value of their work skyrockets.

But what about the rest of us, those who want to collect a few pieces by a certain artist or invest in a few original paintings? Was *U.S. News and World Report* accurate in 1967 suggesting one reason for the boom in art was that it had become a good investment? Dr. McCracken thinks so. "I've been

preaching for many years that good American art, and in particular good western art, is a far better investment than money in the bank."

U.S. News and World Report, for its part, quoted a New York gallery owner as saying that American paintings were the best hedge one could find against inflation. "Many of the most famous artists are dead. Their works are no longer being produced. Their value can go only one way and that is up."

A year earlier, Michael Kennedy, then director of the Montana Historical Society, pointed out several explanations for the soaring prices and popularity of everything concerning Western Americana, including art. "Among these are the tremendous appeal of Western drama on television and in the movies; growing interest in U.S. history; recognition of the genuine talents and craftsmanship of these artists; the popularization of the arts in this country," Kennedy said. "In addition, Western Americana, like the paintings of other schools, have become a status symbol."

Whatever the reason, the fact remains that western art has been a growth industry in the Northern Rockies — and elsewhere, for that matter — through three recessions and an inflation rate that makes the 1967 situation look minor.

chapter eleven
Thinning The Herd

CATTLE HERDS are always being thinned out. That must happen to keep the herd dynamic, healthy, and producing. Some die, others are culled and put to other use, and some are moved to other pastures. New stock is brought in or born in, and what's left is better for it. A strength and vitality comes from such a process.

Much the same thing has happened, is happening, with art and artists in the region. For one reason or another, the herd is constantly in a process of being thinned out and replenished. From this process it gets its vitality, its hope and its promise.

"This has been one of the most positive movements for the region's art. Quality is now the name of the game," Montana artist, Tucker Smith, said.

Landscape painter Mike Coleman suggested the dynamic is not new, just more obvious now with the growth of interest in western art. Older artists had their identity and the newer ones are establishing theirs. But he carried it one step further. As the thinning process occurs, it affects not only the individuals involved, but the overall herd too. Quantity is not the

110

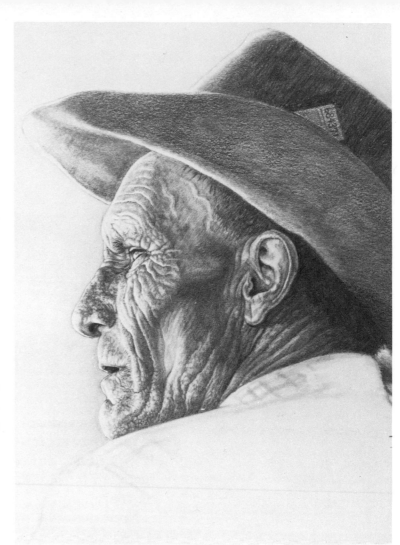

TOM SAUBERT
Paul Sperry
Courtesy of the artist

only change. Quality is altered as well, for good or bad, because, unlike a cattle herd where an outside force imposes judgment and direction, the dynamic in art is subject to unimaginable variation.

Two of the region's most promising artists, one in Wyoming and the other in northwestern Montana commented when I mentioned the competitiveness of artists in the region for markets, shows, outlets for their work. "It's a tough business, very competitive, even dog-eat-dog," Mike Poulsen of Wyoming, said. "You face intense competition all the time. Many people have moved into the area, some of them good, some bad. But they're here. And others have come in to capitalize on the present interest in art." Tom Saubert of Montana acknowledged the competitiveness of the business side of art, but insisted that dimension has no influence on what he does, or how he does it. "As an artist, I don't compete with any other

111

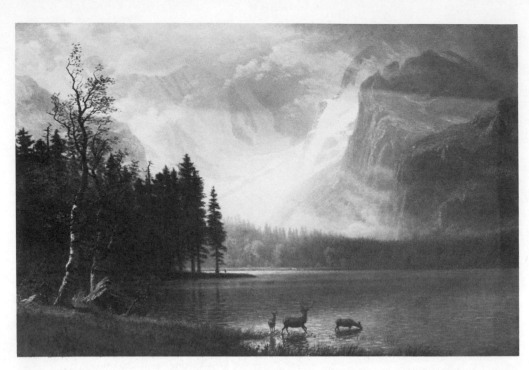

ALBERT BIERSTADT
Grand Tetons
Courtesy:
Buffalo Bill Historical Center
Cody, Wyoming

artist," Saubert said. "Perhaps the 'system,' with its galleries, shows, awards, dealers and dollars, creates competition, but from my heart towards another man's creation, there is none. If my motivation were based on such worldly adulation, esteem, endearment, or monetary gain, then my creation would be truly empty."

Nonetheless, the dynamic is tied to economics and that has a force all its own. As mentioned earlier, both professional and private collectors become more sophisticated as their involvement continues. Competition exists not only among artists for clients, but among collectors for artists as well. Somewhere in that cycle of developing sophistication is the dealer; his or her stake affects the thinning of the herd, too. Some artists, championed by a certain dealer, flourish for a time and then fade into obscurity. Their work doesn't match up to the ballyhoo, and the public discards them, culls them. Others emerge from the pack with an impetus that overwhelms the field, and suddenly there is a clamor for their work.

"There is an evolutionary process at work," John Brice said. "With the opening up of markets comes competition and, ultimately, fairness. And as people who buy art become more knowledgeable about the essence of an area, about the artists working in it, they become critical and they look for the nebulous things that give a work meaning. Subtleties begin to

112

count and the fact is that a lot of Johnny-come-lately artists just don't catch onto those subtleties. That's where and when the thinning process starts."

It does go on, however. A case in point is the featuring of certain artists in *New Interpretations,* published in 1969. Of the twenty-five individuals selected for the book as representative of what was then going on with art in Montana, four are dead, six have little or no active involvement in art today, and another six or seven are at about the same level of involvement they were then.

Several of the artists biographically sketched in the book have achieved widespread acclaim, even a celebrity status in the field. These include Bob Scriver of Browning, Fred Fellows of Bigfork, Gary Schildt of Kalispell, Elmer Sprunger of Bigfork, Bob Morgan of Helena and J.K. Ralston of Billings.

More significantly, there are literally dozens of young artists and newcomers working the field in the region today. Dozens, including many whose careers were just getting underway in the late 1960s, have already achieved considerable recognition: Steve Seltzer of Great Falls; Tucker Smith of Clancy; Tom Sander of Kalispell; and Sheryl Bodily of Columbia Falls. John Clymer of Wyoming, who in the late 1960s had just set aside an outstanding career in commercial art and wildlife painting in the East, might be included in the list.

The success of many of these new artists, particularly people like Utah's Michael Coleman with his exquisite "tepee paintings" and Gary Carter of West Yellowstone, with his powerful story-telling paintings, has inspired others to move to the area. A bandwagon effect is underway and some have concern for what this influx is doing to both art and artists. Some artists of little talent or dedication fall by the wayside, but four or five quickly step up to fill their place.

This is not always to the benefit of the new artists, in spite of an observation made by landscape painter Clyde Aspevig. He suggests that the influx of many new artists will result in higher quality art being produced in the region. Others fear that a lot of the newcomers, particularly younger artists still developing, will be hurt professionally by a leap onto the bandwagon.

"My greatest concern is that too many men and women are

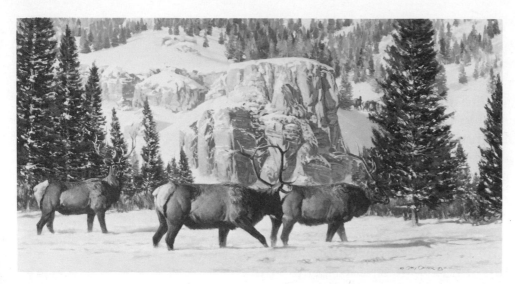

GARY CARTER
A Gallatin Stalk
Courtesy of the artist

'jumping on the bandwagon' before their talents are sufficient to justify having a dealer handle their work or to have advertisements," Veryl Goodnight said. "I'm afraid that the great vehicle of fine art magazines that are being published now are placing many artists in a position where they are much more concerned with the business aspect than they are with developing their own work."

John Brice agreed, raising the fear that some young artists with tremendous talent simply burn out or quit because they can't live up to their expectations, to the reputations their own promotional literature fosters.

"There is a large number of the kind of 'instant artist' who hopes to jump on a bandwagon without paying any dues... I generally feel the scene may be too fast and rich, and cluttered with poor quality, and could result in a burst bubble," Robert Bateman of Milton, Ontario, said.

Whether or not the bubble bursts, and it appears unlikely at this moment that it will, one fact emerges from that process. Change is inevitable, not only in terms of who is involved, but what is done.

Painter-sculptor Gary Carter sees promise of improvement in that. "Techniques are ever growing and surpassing what was done earlier, due in part to new types of pigment such as acrylics and alkyds. Education, depending on school, allows artists to master their craft at earlier stages. Schools that

114

teach drawing are becoming more scarce. Too many schools are teaching shortcuts such as projection and not emphasizing the process of designing a painting — hence, paintings that encompass just that which can be framed in a 35 mm slide.''

Misgivings exist about this direction, perhaps best expressed by sculptor Joe Halko. "The region's art seems to be getting more and more photographic in technique," Halko wrote. "I'm not sure this is a good direction. More and more artists will lean toward just copying a good photographic image, interpreting what a camera may see and not what the artist might see or feel."

Still, there is the other side of the coin — that drive, ambition, hope, muse; call it what you will, that gives an artist inspiration. Motivation comes from many things and it seems that two fundamental requirements represent the constant in those who stay with the herd and those who do not. The first and basic one is talent or ability. The second is perseverance.

"For the most part, art is like any other business. You have to hang in there," Ron Jenkins, the wildlife artist, said. "We have an enormous amount of talent in the area; but we all have our 'niche' and seem to cruise along doing what we do best."

Is it possible to predict who stays with the herd and who does not? Not always, Dr. Harold McCracken offered. "No

CLYDE ASPEVIG
Morning Frost
Courtesy of the artist

John Halko
Artist working on a sculpture

one can tell the future of any artist's work. There are too many variables, including the personalities of the artists involved."

Dr. McCracken suggested that individuals interested in buying art of the West would have to make up their own minds as to what they did or did not collect and, in turn influence the artists' work that way.

"Fine art is that art which strongly appeals to a large number of critical people over a long period of time," McCracken said, pausing carefully to select the qualifying word critical. "In other words, if you're the best artist in your field, the mere fact that you might paint only a half-dozen paintings and they were buried from the public view would mean your reputation wouldn't be enhanced. If the work of an artist's self-promotion isn't quite as good as his art, that is a hindrance to the epitome of reaching success."

Peter H. Hassrick, director of the Buffalo Bill Historical Center at Cody, set the tone of such considerations in the preface to a small booklet the center issued in 1978,

116

Contemporary Western Artists. It featured vignettes on twelve contemporary artists, including Robert Scriver from Montana, Michael Coleman of Utah, and John Clymer, Nick Eggenhofer, Conrad Schwiering, and Harry Jackson of Wyoming.

"There is little question that the West will always spur vital and telling artistic expression," Hassrick wrote. "Though perhaps some artists have failed to keep abreast of their times in terms of artistic output, many others have continued to transform the spirit, style, and subject of past examples into evocative amalgamations of modern aesthetic and regional focus. It is to these artists that the world will look to carry on the traditions and forces long established in the art of Western America."

HARRY JACKSON
Sacajawea
Cody, Wyoming

117

chapter twelve
A Word Of Caution

QUESTIONS OF ETHICS arise in both the production and business ends of western art, as it does in any other enterprise. Consider, for example, this "confession" of an artist who now realizes that what he did was wrong: "Ten years ago I saw hundreds of no talents who jumped on the western bandwagon and cranked out tons of junk and sold everything. I have a few pot-boilers from that period and was connected to a gallery that sold my paintings wet. I was doing a 20x30-inch painting every day and finally burned out. It was really big business. I'm lucky, because I realized this was not what I spent six years in college for, but I had a manager and a top-notch gallery and this is what they wanted. I was their 'star' and I supported the whole gallery."

Few enterprises are as vulnerable to the manipulations of con men and crooks as art; and western art is no exception. Forgeries, illegal copies of sculpture, overpricing, misrepresentation, pot-boilers, and the aggressive selling of a famous "signature" over admittedly inferior work to gullible new collectors occur all the time.

The sole motto is not *caveat emptor* — let the buyer beware.

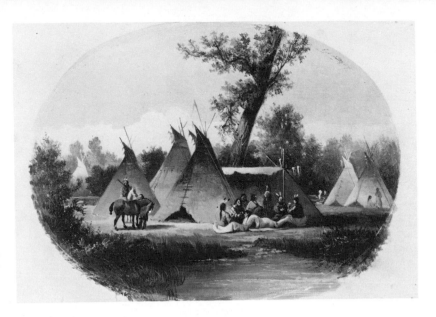

JOHN MIX STANLEY

*Assiniboin Encampment
on the Upper Missouri*

Courtesy:
Detroit Institute of Arts
Detroit, Michigan

There is an equally aggressive effort by reputable dealers, artist organizations and individual collectors to police the buying and selling of art. So much money is involved in so many individual, often secretive transactions, that it is impossible to weed out all the illegal and unethical practices.

Forgeries of past masters like Russell and Remington are the most common deceptions, but living artists are victimized, too.

Some time ago, sculptor Bob Scriver and I, during a break in an interview and picture session for a magazine article I was doing about him, went to a local Browning tourist establishment for lunch. On the way in, he stopped and pointed to a small bronze object.

"There's a copy of my work, straight from Taiwan," he said. "They're all over the area."

The poorly-made, illegal casting of a mountain goat sold for peanuts and there was no question that one of Scriver's small wildlife bronzes had served as the original. It was presented as one of several showing Rocky Mountain wildlife, and one wondered if the sales blurb might have been, had the proprietors not seen me come in with Scriver, that the piece was the creation of the famous sculptor whose studio was a few blocks up the street.

One man who has had experience ferreting out phony C.M. Russell paintings is Montana artist Bob Morgan, a recognized expert on Russell's work. Part of Morgan's job for years at the Montana Historical Society was to analyze and determine whether a work was by Russell or if it was a fake.

There were plenty of fakes, too, as there are today with

CHARLES M. RUSSELL

La Verendryes
Discover the Rocky Mountains

Courtesy:
Amon Carter Museum
Fort Worth, Texas

other artists. The boom in the western art market has brought with it the potential for chicanery. *U.S. News and World Report* noted: "With the growing interest in American art, fakes and forgeries are becoming more and more numerous. Experts advise would-be collectors to protect their investments by sticking with reputable dealers... And, if you ever suspect that a painting is faked or forged after you have bought it, a reputable dealer can be expected to take it back, and refund your money, even if he is able to prove that the work is the real thing."

I asked some dealers about that. Some said they would refund, others would not, if the piece of work involved was not genuine. All suggested that people interested in buying art, particularly those purported to be by a big name artist like Russell, Remington, Bierstadt, J.M. Stanley, Paxson, O.C. Seltzer, Schreyvogel, etc., check the painting out with an acknowledged expert before completing the transaction.

Such verifications are often difficult, if not impossible, however. There is considerable competition among buyers for a representative piece, any piece, by an early artist. They want the "signature" among their collection and often are willing to take the risk rather than chance losing the purchase to another collector. "They want to be able to say they own a Russell, a Seltzer, a Paxson or what-have-you," one dealer said. "It's a prestige thing."

Signature selling — and buying — is a sore point with some in the western art field. The fact is that a "signature" like C.M. Russell, E.S. Paxson, or O.C. Seltzer can add thousands of dollars to the selling price of one of their poorer pieces of work.

Dick Ettinger, of the Flathead Lake Galleries, provided an example. A limited edition *print* recently released of a Russell painting sells for about $100. "If it had Russell's signature on it, it would probably go for about $4,000. That's what it means to have a piece signed by the artist."

Kathe McGehee, editor of *Art West* magazine, is outspoken in her denunciation of most signature selling. "Most of what we're seeing represents the artist's culls. That's why so much of it is available. People are willing to part with it. Some prices are underhanded, outrageous. Just because they're based on an autograph. Some art is misrepresented, sold for exorbitant prices. They're culls that are easy to sell, or part with. Let's not get into autograph trading and call it investments."

McGehee suggested, as an example, that most of the O.C. Seltzer work now on the market does not represent his better work.

Dr. Harold McCracken said that signature trading has been around for a long time. "Dogs we called them," he said, expressing amazement at some of the prices these works draw.

"Art is a good investment, but it requires considerable study and caution to put together a good collection," McGehee said. Her advice: "Study, study, and make your own decisions. Don't be talked into something, and ultimately decide on a piece you can live with." She noted that *Art West* devotes considerable space to prices, shows, and art ac-

EDGAR PAXSON *Arrival of Father Ravalli at Fort Owen, Montana, 1845*
Mural in County Courthouse, Missoula, Montana

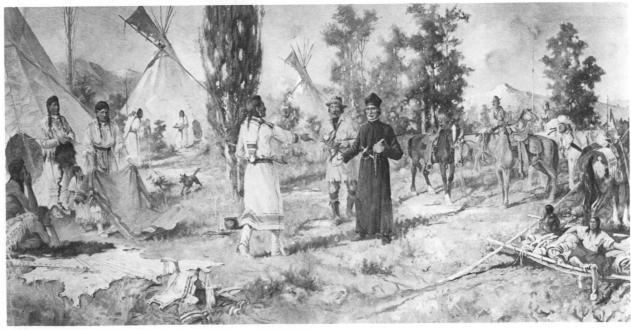

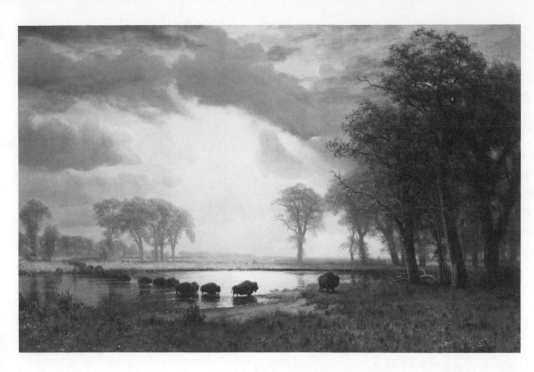

ALBERT BIERSTADT
Buffalo Trail
Courtesy:
Museum of Fine Arts
Boston, Massachusetts

tivities as a service to people interested in arts. "We can do a service to our readers in a way some of the artists can't." Exposure to such information on a regular basis through such vehicles as *Art West* has combined with other factors to establish a more open market in Western art, though "road agentry" still exists. "Unfortunately, it happens all the time," McGehee answered in response to a suggestion that pricing was no longer underhanded or outrageous.

Even so, long-time observers like Bob Morgan believe the situation is much better than it was even a decade ago. "People are becoming more sophisticated, and we are much more open about such things, given the number of shows and galleries now in business. Most people know what the going prices are for a particular artist's work and they don't get ripped off as often."

But what about outright forgeries? They're out there, Morgan advised. And the gullible who get taken in include not only the neophytes but professional gallery people, too. Russell's work, because of his great popularity, is the most often copied and passed off as original.

Morgan said that Russell copiers work in a variety of ways. Some paint a copy of the original and try to pass it off as the real thing. Others lift figures from several of Russell's paintings and put them in one work, while still others use someone

122

else's works and put Russell's name on them. The artist's illustrated letters are a favorite of the forgery trade, along with the production of watercolors from many of his pen and ink sketches. "I've never seen an out-and-out forgery that approached Russell's capabilities." Among common mistakes of the forger is to make their painting larger than Russell's original, or use colors from a print that isn't true to the original. "Many forgers make their mistake when they try to copy Russell's signature. He had eight or nine he used in different periods of his work."

Frederic Renner, who is perhaps the world's foremost authority on Russell, has done considerable writing and lecturing on the subject of forgeries of Russell art. An excellent article by Renner on the subject appeared in the Spring 1956 issue of *Montana, the Magazine of Western History* — indicating that the present-day phenomenon is nothing new; the stakes are just bigger nowadays.

"One of the many authentic touches that characterize Russell's meticulous work are the typical brands he usually painted on the shoulder, ribs, or hip of his animals," Renner wrote. "This brand is one of a number of things to look for in examining a painting about which there may be some question. The seventy-five to a hundred different brands Russell used were not just any kind of mark. They were real ones that belonged to existing outfits whose animals he painted, as proven by a painstaking check of the official records of the Montana State and County Livestock Associations."

Sometimes the owner of a piece won't accept the judgment that the work is a fake. In one noteworthy incident, an individual who had put together a rather massive collection of what he believed to be Russell originals found out they weren't. His solution: he broke up his collection and sold them as originals!

Maybe it is *caveat emptor,* after all. Morgan suggested the best protection a collector/buyer of western art can have is caution. "The real investors in our art *know* when they buy something that it's authentic. That's the same practice everybody should use. Take your time. Check it out. Be sure."

chapter thirteen
Rendezvous With Tomorrow

INSTITUTIONAL STABILITY has come to the art of the Northern Rockies, but with it has come a guarantee of accelerated change. Today's artists want to write their own script. They see the West in ways no one before them has; more than ever, the trend is toward interpretation of the West of today.

"Probably most people would agree that the primary interest of collectors and dealers at this time is in the very tight, realistic 'cowboy and/or Indian art,' " M.L. "Mike" Coleman suggested. "Obviously the popularity of Russell, *etal,* and the 'Old West' promotions have been a major factor, but I feel there is a saturation point that will be reached sooner or later. I believe that interest in landscape, wildlife and other subjects related to the area will continue to increase. I also feel that as collectors live with their art, the demand for extremely 'tight' and one hundred percent authentic details will decrease. An increase in viewer sophistication will put *feeling* and *artistic merit* ahead of details and extreme accuracy."

General agreement with such notions come from many artists of diverse styles, including Clyde Aspevig, Hall Diteman, Ron Jenkins and Tucker Smith of Montana and wildlife

124

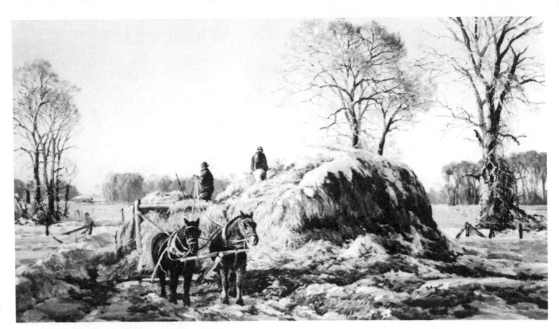

CLYDE ASPEVIG
Morning Feeding
Courtesy of the artist

sculptor-artist Veryl Goodnight of Colorado:

"The region's interpretive art might take a turn toward more impressionism, but I don't think it will ever completely go away from illustrative techniques or realism," Jenkins declared, "but there already is a trend toward a more impressionist style. Some watercolorists have successfully achieved some acceptance and I have noticed a few oil painters leaning toward looser application of paint while still capturing the realistic essence of their subject."

Could he suggest a time frame in which this might happen? No, and it might not happen. Jenkins noted that the appearance of some impressionist-oriented art in the scene several years ago faded in popularity. The buying public didn't want it.

Coloradoan Goodnight suggests that the artistic future she sees in the region involves wildlife, historical scenics and ranch-type subject matters. Tucker Smith offers that there will be less historical western and more contemporary subject matter. "And more good landscape," Smith said. "I think we will see a broad spectrum of techniques. This is a very diverse place, geographically, socially, and philosophically. Its art should also be diverse."

Aspevig, as might be expected, thought contemporary landscapes would gain in acceptance as the face of the region

MARV ENES
The Whisper
Courtesy of the artist

is changed with industrial development projects. The thoughtful John R. Brice qualified that notion. "My guess is that more of the same will occur. I even suspect that those artists most revered right now as illustrators and mentors are not going to talk about Colstrip Three and Four, strip mining, or anything like that. They'll continue to paint what they have. It sells."

Subtle changes are occurring, however. More and more artists are focusing on contemporary themes. New history that may ultimately rival the romance of the Old West is being made and is finding its way onto artists' canvases.

If, as John Brice suggests, art is "nothing more than a conversation an artist has with himself or herself and what's out there," it is likely the region and its changes will be expressed in its future art. So will its past, which in many aspects is so similar to its present form as to be indistinguishable. Examples include ranching, wildlife, and nature scenes.

A helpful perspective came from Verne Tossey of Portland, many of whose canvases reflect scenes of activities in the Northern Rockies. He feels that in a modern, computerized society the western ranch with its hardy people represents one of the last bastions of rugged individualism, integrity and resourcefulness in the country.

Bob Morgan believes that eventually the interpretive art of the region will assume artistic integrity through impres-

sionistic techniques rather than illustrative quality. "As collectors become more and more involved in the art offered for sale, they also become more and more knowledgeable about art and what comprises good, solid art works. I have seen this happen over the years and can recall several instances where collections have been completely renovated, so to speak, because of the growth of the collector. Subject matter is never involved totally in the selection of a painting, but rather a combination of three elements in the make-up of a good painting — drawing, composition and color. These three elements are essential in the execution of any work of art, regardless of technique, subject or artistic whim."

Inspiration is another major force, coupled with skill, that sculptor Bob Scriver wrote me about. "Here is a little saying

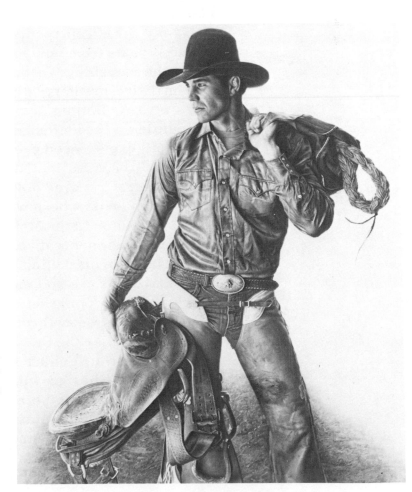

JIM BAMA
Butch Kelly, Bronc Rider
Courtesy of the artist

127

of my own that I like to spout at various, and rather serious times: 'Great art transcends the artist.' I truly believe that the finest pieces of art an artist does come about by some great inspiration experiences and he is driven by a force greater than he. He is just the instrument or tool to bring it forth — consider the great Michelangelo work or the work of Rodin. How could mortal man conceive and execute such tremendous art? Not to compare myself in the company with the immortals in art, but I have done three or four pieces in my life that were inspired by a force much greater than I... I know that they far transcend what I am ordinarily capable of doing."

M.C. "Mike" Poulsen finds his inspiration in what he sees vanishing before him in Wyoming. "The old people of today are passing away and by and large we've neglected them. There are only a handful of the real old-timers still around. I guess my art is representational, but it may help people a hundred years from now realize that I'm making a statement about the vanishing West of today."

John Brice predicts "phenomenal increases" in two art forms already finding favor, as art of the region moves into the eighties — the limited, numbered print and bronze sculpture. Both experienced exceptional popularity in the seventies, largely because limited editions enable those who cannot afford several hundred dollars for an original oil painting to buy into an artist whose works they like.

Art West editor Kathe McGehee suggested that these things represent a new generation at work in the art field — particularly in terms of marketing. "The marketing techniques of the 1950s and 1960s are no longer appropriate. The younger artists know how to market their work."

One way has been through the establishment of promotional groups, like the Cowboy Artists of America, organized in 1965. This group deliberately limits its membership, and as art of the West has grown, a variety of organizations have sprung up to achieve both identity and promotional legitimacy for its members. Many artists of the Northern Rockies region noted that the formation of the Northwest Rendezvous Group in 1979, a promotional group, found immediate acceptance and guaranteed for the region a special artistic identity.

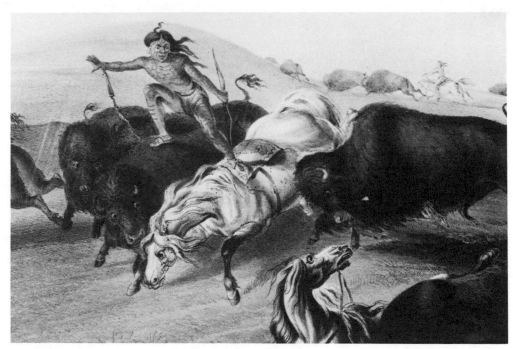

GEORGE CATLIN

Buffalo Hunt: Disaster

Courtesy:
Buffalo Bill Historical Center
Cody, Wyoming

"The Northwest Rendezvous Group is the embodiment of art of the region," editor McGehee affirmed. The group had its roots in an earlier one with a similar name, but without formal organization. In 1972 the Montana Historical Society conducted the first "Rendezvous of Western Art" in Helena, but through the years it slowly declined in importance and influence. Personnel at the Society changed through the 1970s, and the result was a loss of the focus and dedication to the Rendezvous idea.

Then, in 1979, Bob Morgan and Jack Hines of Big Timber suggested establishment of the Northwest Rendezvous Group. Twenty-three artists participated as founding members.

"Our goals are not commercial, but rather based on a strong feeling that art of the Western genre should be firmly rooted in the history of the region," Jack Hines said. "The past has much to teach us about our condition today. This is, after all, a land once peopled by Lewis and Clark, Karl Bodmer, Alfred Jacob Miller, John Bozeman and Thomas Moran, Sitting Bull and Charles M. Russell. The list is not only endless, but implies the color and diversity which characterize our roots."

Hines noted that the group wants contemporary art of the American West to reflect the color and diversity of its history

in a way that is authentic and meaningful but also artistically fine, regardless of technique or style of expression.

Significantly, the Northwest Rendezvous Group organized in the region but reached beyond it for membership. Some artists who live elsewhere paint and sculpt subjects of the region; thus, its membership includes artists from such diverse places as the Northern Rockies, Maine, Oregon, Alaska, Colorado, Arizona, Connecticut and Washington.

This diversity of artists helps to perpetuate the vitality of the region in the hearts and minds of those who view their work. Each artist, then or now, can show only their own interpretation of a specific brush with the West — and that is exactly how it should be.

Selected Bibliography

Ainsworth, Ed. *The Cowboy in Art.* New York: The World Publishing Company, 1968.

Bama, James. *The Western Art of James Bama.* New York: Peacock Press/Bantam Books, 1975.

Beebe, Lucius, and Clegg, Charles. *The American West.* New York: Bonanza Books, 1955.

Burk, Dale A. *New Interpretations.* Stevensville, Montana: Western Life Publications, 1969.

Catlin, George (edited by Michael Mooney). *Letters and Notes on the North American Indians.* New York: Clarkson N. Potter, Inc., 1975.

Curry, Larry. *The American West.* New York: The Viking Press, Inc. in association with The Los Angeles County Museum of Art, 1972.

DeVoto, Bernard. *Across the Wide Missouri.* Boston: Houghton Mifflin Co., 1947.

Eide, Ingvard Henry. *American Odyssey.* New York: Rand McNally and Company, 1969.

Elman, Robert. *The Great American Shooting Prints.* New York: Alfred A. Knopf, 1972.

Ewers, John C. *Artists of the Old West.* Garden City, New York: Doubleday and Co., 1965.

McCracken, Harold. *The Charles M. Russell Book, the Life and Work of the Cowboy Artist.* Garden City, New York: Doubleday and Co., 1957.

—. *Frederic Remington, Artist of the Old West.* Philadelphia: J.B. Lippincott, Co., 1947.

—. *George Catlin and the Old Frontier.* New York: Dial Press, 1959.

Rossi, Paul A. and Hunt, David C. *The Art of the Old West.* New York: Alfred A. Knopf, 1971.

Renner, Frederic G. *Charles M. Russell: Painting, Drawings and Sculpture in the Amon G. Carter Collection.* Austin: University of Texas Press, 1966.

Russell, C.M. *Trails Plowed Under.* New York: Doubleday and Co., 1927.

Scriver, Bob. *An Honest Try.* Kansas City, Missouri: The Lowell Press, 1975.

Taft, Robert. *Artists and Illustrators of the Old West, 1850-1900.* New York: Charles Scribner's Sons, 1953.

Index

Italicized page numbers refer to illustrations or plates

BANFF

CALGARY

RED DEER R.

BOW R.

MEDICINE HAT

LETHBRIDGE

KALISPELL

SPOKANE

BIGFORK

MISSOURI R.

GREAT FALLS

MISSOULA

HELENA

YELLOWSTONE R.

BOZEMAN

BILLINGS

SHERIDAN

CODY

BOISE

JACKSON

SNAKE R.

N. PLATTE R.

LARAMIE

CHEYE

SALT LAKE CITY

S. PLATTE R.

DENVER